Accession no.
36287124

Young New York

Ethan James Green
Young New York

Foreword by Hari Nef
Essay by Michael Schulman

LIS - LIBRARY

Date	Fund
3.7.2019	t-War

Order No.

O 2963887

University of Chester

aperture

Foreword
Hari Nef

Five years ago, I met Ethan James Green in a nightclub.

He found me sucking down a cigarette in an alley behind Up & Down, a swanky club usually frequented by Russian models and buttoned-down financiers. Big checks lured downtown DJs all the way up to Fourteenth Street, and the kids followed. We'd tear up the floor, dodging $14 cocktails by sipping on a stranger's bottle. Our domain, until then, had been limited to Bushwick raves and East Village dives.

We were thrilled—secretly—to party in a posh space like Up & Down, rubbing shoulders with A$APs and Hadids. We posed for party pics and posted them on Instagram, our new favorite app. Thursdays we got high, or merely felt like it—soaring to a place we couldn't quite name but grew up wanting to be. Fridays were different. "Queer night," "Black night," "Tranny night"; I'd come to hear management describe Up & Down Fridays in a myriad of colorful ways—usually through a snicker, or a barely stifled sneer. Fridays were a night for everyone else.

Ethan walked up to me, coy and stammering, not possibly knowing that I knew exactly who he was. In fact, I'd had a crush on him since I was fifteen. Ethan was the most elegant of a certain crop of male models who began to dominate runways and editorials around the beginning of the decade: rakish, sleepy-eyed, feminine with mosh-pit swagger. I knew Ethan from spreads by Steven Meisel and David Armstrong—not to mention the fashion web forums where I'd discovered the likes of him, Cole Mohr, and Luke Worrall. I found them dreamy; I dreamed of New York.

Ethan asked if he could photograph me. Of course he could.

"Maybe," I purred, "are you any good?" He explained that he'd recently taken up photography, but struggled to find fascinating subjects. I asked him if he found me fascinating. He said he did, which would have rolled my eyes if he'd seemed less earnest. Ethan was wearing a cowboy hat. I snatched it off his head and wore it for the rest of the night.

About a week later, I slumped, glaring into Ethan's lens. My brows were shaved; I wore Daisy Dukes and a faux-crocodile crop top. Ethan liked to

shoot at dusk in a park, smack in the middle of a Lower East Side housing project. I felt vulnerable shooting, especially in public. It might have been my fifth time in front of the camera.

"Can you try something with your hands?"

"What do you mean?" I squeaked. Ethan's camera bungeed down around his neck. "You *know*," he chanted, "couture hands. *Avedon* hands. And the neck." Ethan struck a pose, evocative of Richard Avedon's *Dovima with Elephants*, a famed photo from a 1955 edition of *Harper's Bazaar*.

"Like Dovima?" I smiled.

"*Yesssss*," hummed Ethan, impressed.

"I know all that shit," I confessed.

"Yeah?"

"Everyone always tells me to relax, so I don't do it."

"How boring of them."

"Yeah."

"Just give me fashion."

Clichés have a way of rolling out of Ethan's mouth and sounding like revelations. I was breathless. No one had ever asked me to give them "fashion." I extended one leg, straightened my back, craned my neck, and sent a flourish through both arms. I exhaled through my eyes, and into his lens. The camera clicked. "Oh, my *God*," he said, looking down at the preview photo.

I scurried over to see.

Within a year or two, Ethan would be shooting for Miu Miu and Alexander McQueen. I'd become the face of Gucci, and then L'Oréal.

I peered down over Ethan's shoulder and—to my surprise—saw myself.

Young New York
Michael Schulman

They come to New York City every week, more and more of them, in buses and trains and cars, carrying bags, carrying ambitions, carrying the fabulous clothes on their backs. They're the fashion kids, the art kids, the theater kids, the who-knows-what kids—creative renegades of nineteen or twenty or twenty-five. They've heard what we've all heard: that downtown is dead, that the rent is too damn high, that someone has paved paradise and put up a Duane Reade. Still, they keep coming, against all odds, tricked out in spangles, torn shirts, and tattoos, seeking a place where they can find themselves, and each other.

Ethan James Green was one of them. Then he became one of their more stylish chroniclers. Born in 1990, Green is a counterculture portraitist, alive to a New York that still feels, somehow, like a freewheeling Wild West. His subjects—musicians and designers and all manner of "creatives"—are emissaries from a generation that has bushwhacked new expanses of gender expression and been reared on the self-curating powers of social media. "I just feel more calm when I'm with those kids," Green says. "I found the people that I can relate to, being different back home, and then coming here, and then meeting all these people and realizing, Oh, my God, you were there and I was here, looking and dreaming about the same things."

Green's subjects are often in states of transition, whether the transition from youth to adulthood or a gender transition, visible in top-surgery scars or budding breasts. Transitions render people vulnerable, but Green's subjects are confidently beautiful, masters of style and attitude. When he began the project that became this book, Green was a self-described "lone wolf" looking for friends. He found them at clubs, at fashion shows, and on social media. He would invite them to take portraits, often at Corlears Hook Park, where the Lower East Side meets the East River. Person by person, he found what he was looking for, which was connection. Green's portraits are a kind of social network, documenting a community in the making. Almost as a side effect, they reveal what queer identity looks like in the twenty-first century: multiracial, gender-fluid, and empowered.

Androgyny has become something of a trend in the fashion industry, which has sought to capitalize on transgender visibility. While Green has a solid foot in the fashion world, having begun his career as a model and then working as a photographer for brands like Fendi and Prada, his portraits are neither exploitative nor self-consciously hip. Rather, Green democratizes the glamour of fashion photography, just as his subjects have learned to take what they like from the pages of *Vogue* and repurpose it on Instagram. The city is their catwalk, and they are their own gatekeepers. "The kids I photograph really, truly believe they're the ones that are making New York New York again," Green says. "They're what's important right now. They're always going to be important, but right now it's their time."

Green grew up in Caledonia, Michigan, a small town outside of Grand Rapids. His grandmother introduced him to the theater of the imagination. She would turn the living room into a stage set—the couch became a palace—where Green and his cousins would act out stories, complete with costumes. She also taught them how to sew, and at the start of every school year they would shop for fabric and make their own clothes. Green's best friend was his younger cousin Esther, and Green would stage photo shoots to show off her designs.

Adolescence was isolating, as it often is for queer kids. The first day of middle school, Green was in band class, where everyone had to pick a musical instrument to learn. The boys all chose percussion or brass; the girls chose woodwinds. When Green said "flute," the entire class turned and stared at him. "Life changed after that," he recalls. "It was the beginning of being the 'different' one. Being the loner."

Fashion provided a means of escape. As a teenager, Green would frequent Macy's—"That was the one place we had high fashion in Grand Rapids"—and the girls at the cash register told him he should be a model. Rail-thin, he didn't consider himself a masculine ideal, but browsing models.com, he came across bodies like his own. His style was emo and "anti-Abercrombie," and he'd embellish outfits from chain stores with his grandmother's scrap fabric. Through his art teacher, he made a new friend named Lexi, who introduced him to another girl, Saira. "Every day after school, we'd drive to an orchard and take pictures, or be in the driveway of one of our houses," he says. "We were always taking pictures."

In 2007, when Green was seventeen, his father took him to New York to meet with modeling agencies, and he signed with Ford Models. He moved to the city the following year, and modeled for the likes of Calvin Klein and

Marc Jacobs. His interest in being behind the camera temporarily took a back seat, in part because the scale of the fashion world intimidated him: "There were big sets, and I thought I needed this big production to take pictures."

He found his way back to photography through the mentorship of David Armstrong. Part of the Boston School that included Nan Goldin and Mark Morrisroe, Armstrong had captured the sexy and seedy subcultures of disco-era New York, populated by gay men and artists and drug addicts: a demimonde largely wiped out by gentrification and the AIDS epidemic. In his fifties at the time, Armstrong was working on his collection of portraits of young men, *615 Jefferson Avenue* (2011), named for the address of his brownstone in Bedford-Stuyvesant, Brooklyn.

Armstrong found the eighteen-year-old Green through modeling channels and invited him over. Green was entranced by the antique furniture and strewn bric-a-brac. "You were just taken away to some special place," he recalls. "It was like a dream." He was even more intrigued by Armstrong. As Green posed, the photographer came up and tied a Victorian baby dress around his neck. Green, who was gay but not yet out, saw in Armstrong a version of what queer adulthood could be.

Green soon became Armstrong's assistant. "I would go to the house mostly to clean, wipe things down," he remembers. "We would do shoots as well, and it was all natural light. He would have me hold a V-flat or a reflector. He would say, 'Shoot behind my back. Tell me if you find good light.' I couldn't have worked for someone better. All the kids he brought around he just wanted to succeed. He had all these kids who lived in the house or worked with him or just came to talk. He had this great connection to young people."

Armstrong told Green he was welcome to use his place as a testing ground for his own photography. Not long after, Green booked a shoot for *VMAN* magazine and took him up on the offer. He returned to Jefferson Avenue and shot his friend Charlie on a divan. As he was editing images on his computer, Armstrong walked in and said, "Ethan, doll, that's fucking divine!" "He really saved me," Green says. "He believed in me before he even knew what I was doing. When he told me how much I reminded him of when he was my age, that changed my life, because it was right after I realized that I wanted to be just like him."

When Armstrong, who was in and out of good health, decided to sell his place in Bed-Stuy and relocate to Massachusetts, Green organized a sale of his prints. Spending day after day rooting through Armstrong's archives was a revelation. He decided he wanted to shoot "real people"—meaning the people *he* found beautiful, not what the fashion world dictated—just

like the social circle that Armstrong had captured in his 1997 book, *The Silver Cord*. "I thought I would look for the equivalents of the people in David's pictures, but today."

Armstrong died in 2014. That same year, Green was at Up & Down, a nightclub in the Meatpacking District. He went outside to smoke a cigarette and spotted an arresting-looking stranger named Hari Nef, who would go on to become the first openly transgender model to sign a worldwide contract with IMG. "I knew I had to talk to her," Green recalls. "I went up to her and I asked if I could take her picture, and she said yes." The next time they met, Green asked her to bring her friend Ser Brandon-Castro Serpas, an artist. Serpas brought three friends, and those friends had friends, and soon Green found himself capturing not just individuals but a community.

Not that he gave up fashion photography, for which he became increasingly in demand. And he extended his sights beyond youth with a project set at LGBTQ senior-center dances. But it was the monochrome portraits he would eventually collect into the series Young New York that burnished his reputation—and kept drawing subjects to him, like bohemian moths to a flame.

Those images place him in the lineage of artists such as August Sander and Diane Arbus, who had remade portrait photography in their own eras, and with whom Green shares a visual language. Sander, born in 1876, sought to capture the breadth of the German populace across social strata, from farmers to aristocrats, in his multidecade series People of the Twentieth Century. Arbus counted Sander among her chief influences, having first encountered his work in a Swiss magazine in 1960. Her mid-twentieth-century portraits of the marginalized and the outré—nudists, dwarfs, identical twins, carnival performers, musclemen, and the casually idiosyncratic denizens of Central Park—are marked by a tension between intimacy and distance.

Green admires Sander for his "timelessness" and Arbus for her "grittiness," while staking out his own sensibility. His work is often compared to Arbus's: both are drawn to parks, to gender nonconformists, and to a certain directness of gaze. But their differences are perhaps more telling. Whereas Arbus brought out her subjects' strangeness—their otherness—Green emphasizes their beauty and self-possession. Today's trans youth, after all, have the cultural agency to tell their own stories, and Green treats them not as specimens but as collaborators and coconspirators.

One sunny day in May 2018, I met Green at the downtown apartment he uses as a work space. Rows of portraits were tacked up on a bulletin board under a skylight. Green, in sandals, a striped T-shirt, and a denim jacket, sat by a window and blew cigarette smoke through a fraying screen as he waited for three of his latest muses.

The first to arrive was the trans model and musician Torraine Futurum. Dressed in tuxedo pants, a floral crop top, and rhinestone boots, she was sphinx-like when it came to her age ("I'm timeless. I'm stuck in time. *Slaughterhouse-Five*") or how long she'd been in New York ("I materialized as a fully formed adult one day on the L train"), but she had plenty to say about Green, whom she had met through Instagram. "I liked his photos, and I emailed him," she said, "because I was like, I fit in this world."

She was followed by Mica, a trans woman in a blue Prada top, who had moved from Atlanta two years earlier and was between jobs doing PR and helping a friend sell vintage clothing. The last to arrive was Jameel Mohammed, a twenty-three-year-old Chicagoan who cut a striking figure: six and a half feet tall, with a bleached Afro, jewelry he had designed himself, and a mohair jacket. A trained dancer, he had emailed Green two weeks earlier with a photo of himself in an acrobatic pose. This was their first time meeting in person.

The group walked to a shaded lawn in a nearby housing project. There were few residents around, and the ones who passed paid them little mind. Torraine went first. Green cleared away a plastic bag and placed her in front of a zigzagging wall of brick. She put one hand on her hip and fixed the camera with a look of confident serenity. "Gorgeous," Green told her, straddling his legs wide. He wasn't looking for candid moments, necessarily; he shaped and coaxed his subject, feeding her rapid-fire adjustments and praise, which ran the scale from "nice" to "beautiful" to "major" to—on occasions of brilliance—"oof."

"Do something crazy with the arms," he told her. "Make a shape." She linked her lithe arms above her head like a serpent. "*Gorgeous*. Hold that."

After a bit, he showed her the images on his camera screen. "When I'm taking a portrait of someone," he says, "I want it to be both of us working together, and I don't want them to be blind during it." Torraine seemed pleased, but told him, "Don't pick any where I look boxy. Sometimes I look like a Tetris block."

Green laughed and said, "Lies!"

Mica's turn was next. She kneeled in the grass in front of a concrete wall, looking kittenish and demure, like Sandra Dee on a beach. She and Green spoke in a shorthand developed from years of ogling fashion spreads. "Give me Linda neck," he told her, and she knew exactly what to do: an angled

neck perfected in the '90s by the supermodel Linda Evangelista. ("Not a lot of the models can do it anymore," Green sighed.) Behind them, a mop mysteriously fell out of a window. Green told Mica to twist her body like a towel.

"*Oof.* That's beautiful," he said, and showed her the results.

Jameel went last. He had brought a bag of his own 3D-printed jewelry, which he described as a "luxury brand inspired by the African diaspora": chokers and bracelets made of sterling silver and gold, adorned with tiger's-eye. Jameel paired them with white pants and bare feet. "How good are you with jumps?" Green asked.

"Oh, that's what I *live* for."

Jameel leaped into geometrical modern-dance configurations, as Green snapped him midair. They moved to another patch of green, and Jameel bent backward into a remarkable pose: palms on the ground behind him, torso up, one foot balancing on the grass, the other arched skyward. Minutes passed. He trembled slightly, sweating, but kept his face calm.

"I think we got it," Green said.

———————

Nothing lasts forever, especially youth. That first moment of being fresh and full of possibility in New York is ephemeral, as are the relationships that blossom when everyone's on equally uncertain footing. The last time I spoke to Green, he lamented that the network he had captured over three years had begun to fray. Couples had broken up. Friends had stopped speaking to each other. Some people became famous, some didn't. A few had even left the city. And Green himself had evolved. "I'm definitely not one of the kids anymore," he said. "It really was just a moment in time."

But what is any portrait but a moment in time, rendered timeless? Like Sander, like Arbus, like Armstrong, Green makes his subjects part of a history still being written, and in the process makes history all the more inclusive. As Torraine Futurum told me, "I feel like we're in a time that's going to be written about in twenty, thirty years—all these people in New York being around each other and working near each other and doing fashion modeling and art and music and all these things. People are going to see Ethan's photos and go, Oh, my God, all those people knew each other?"

For David

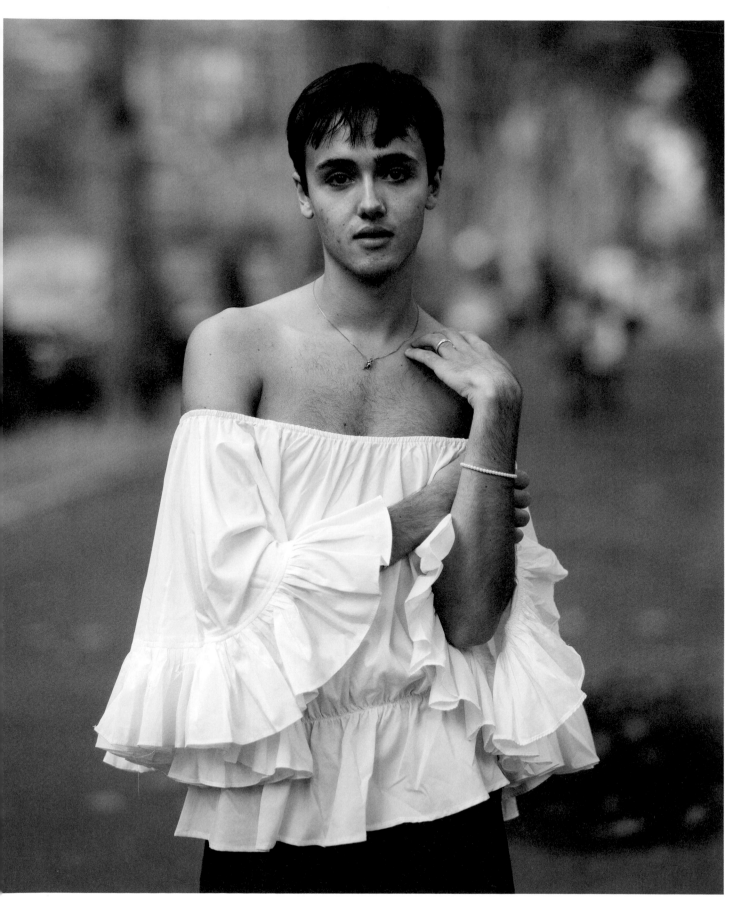

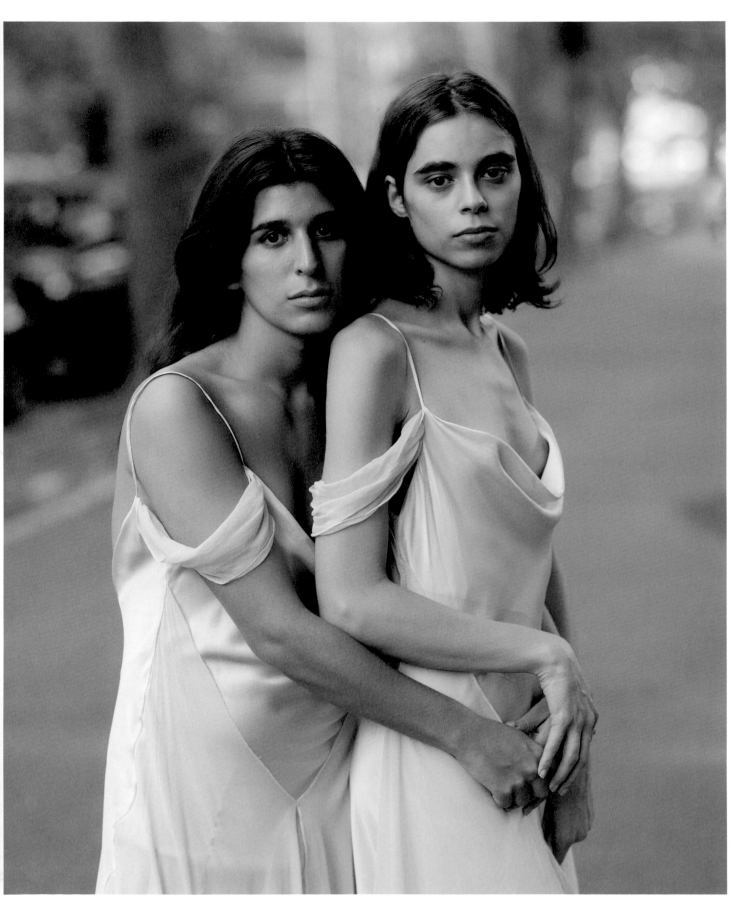

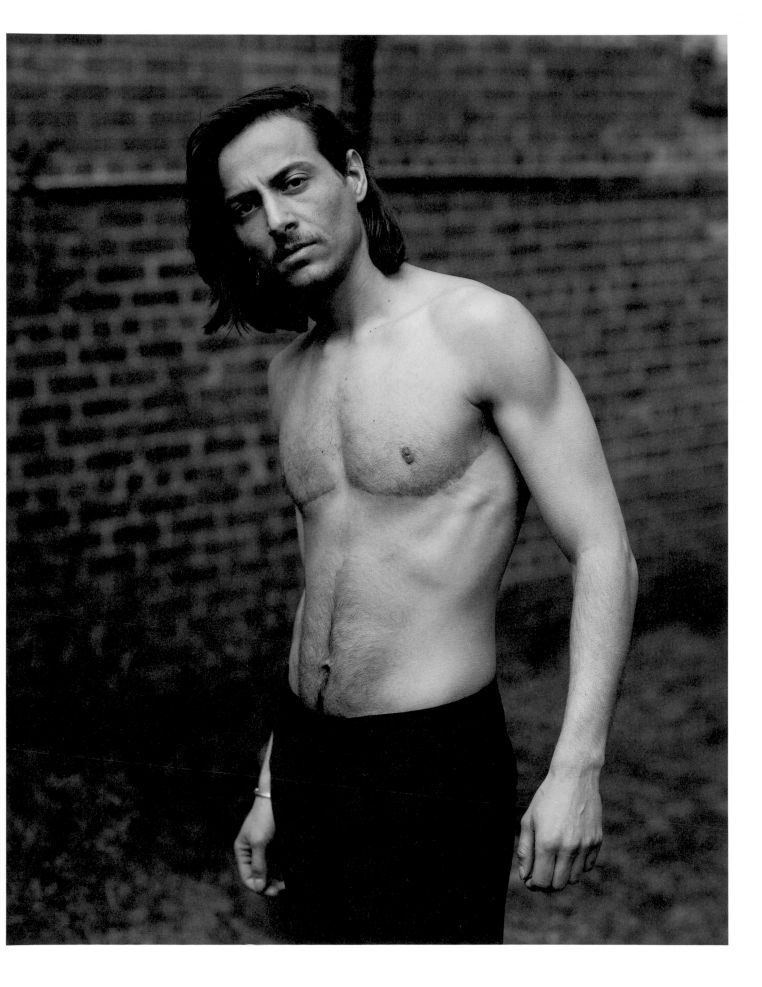

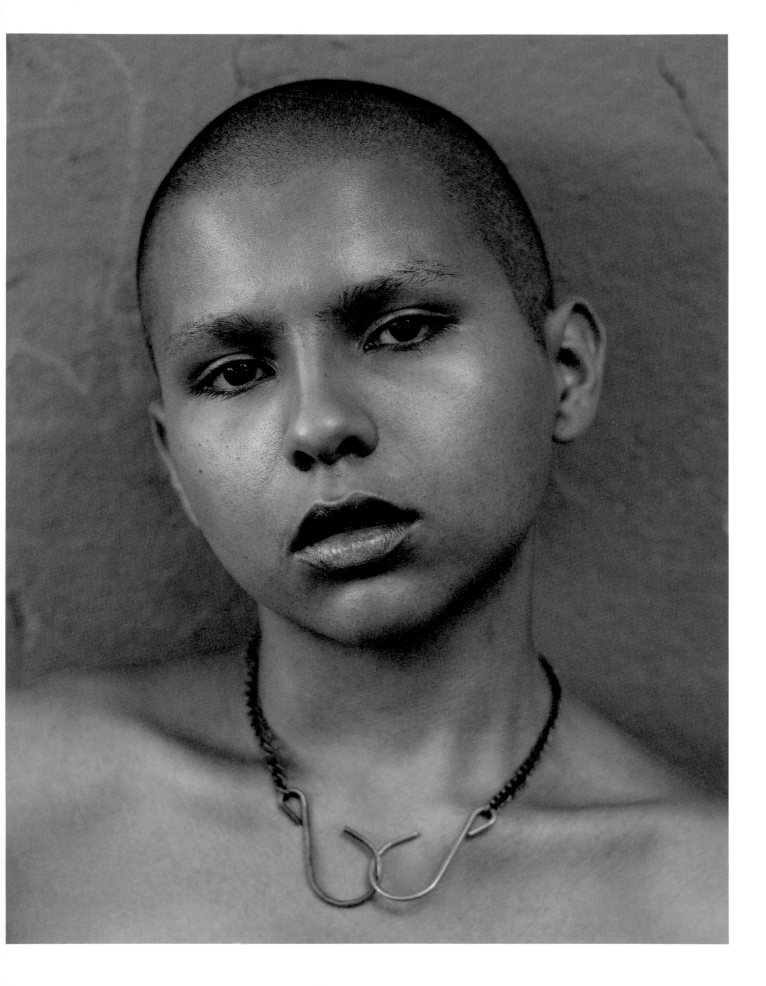

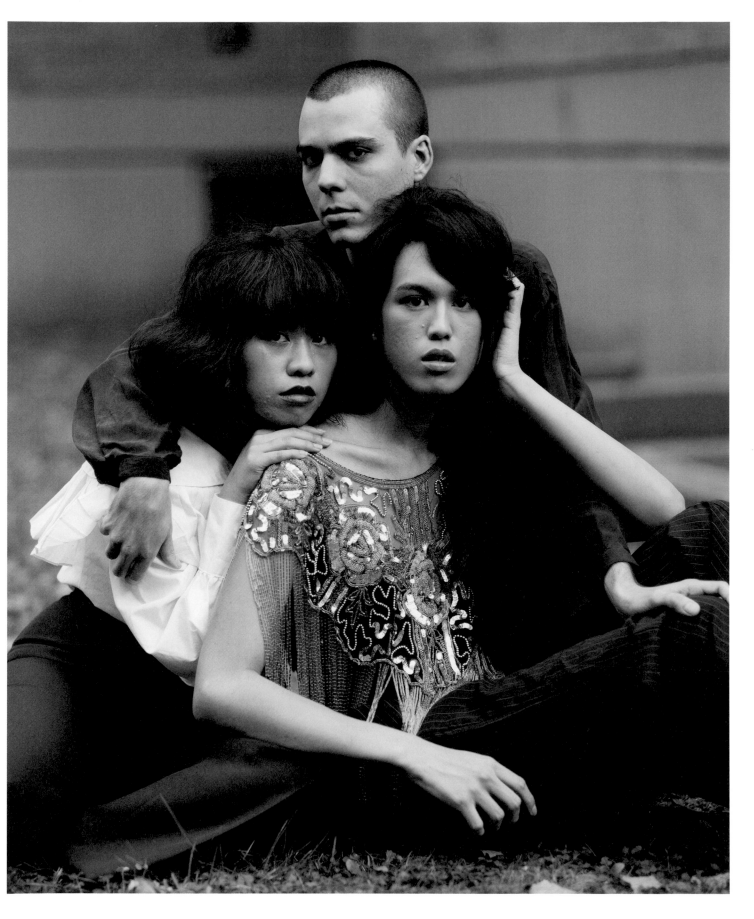

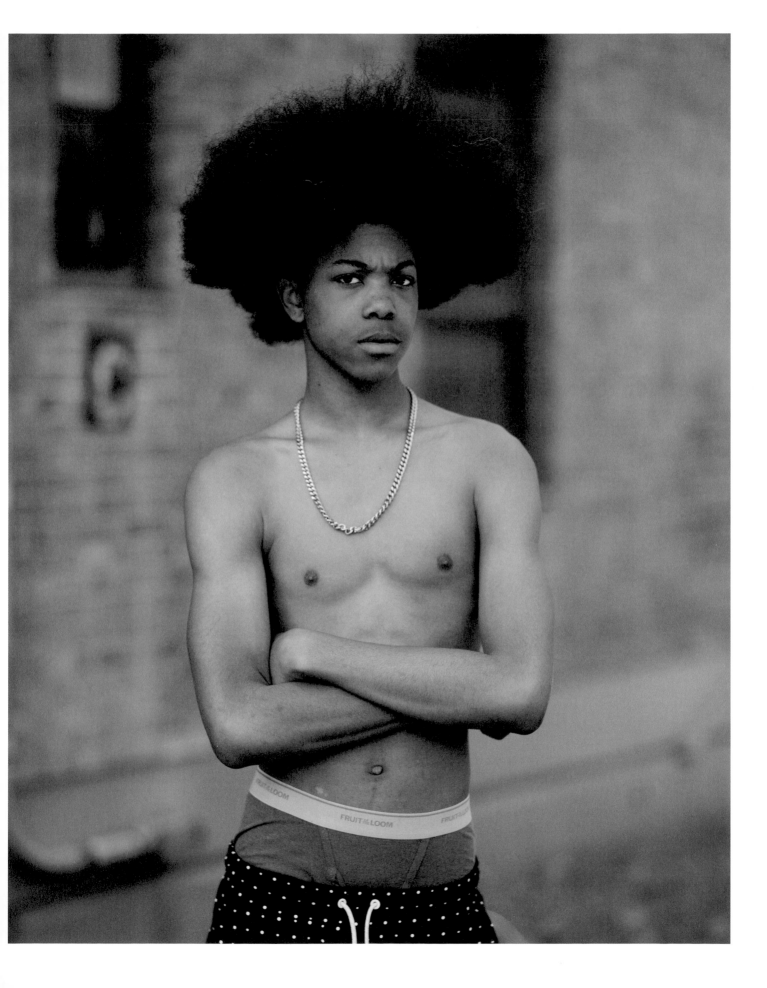

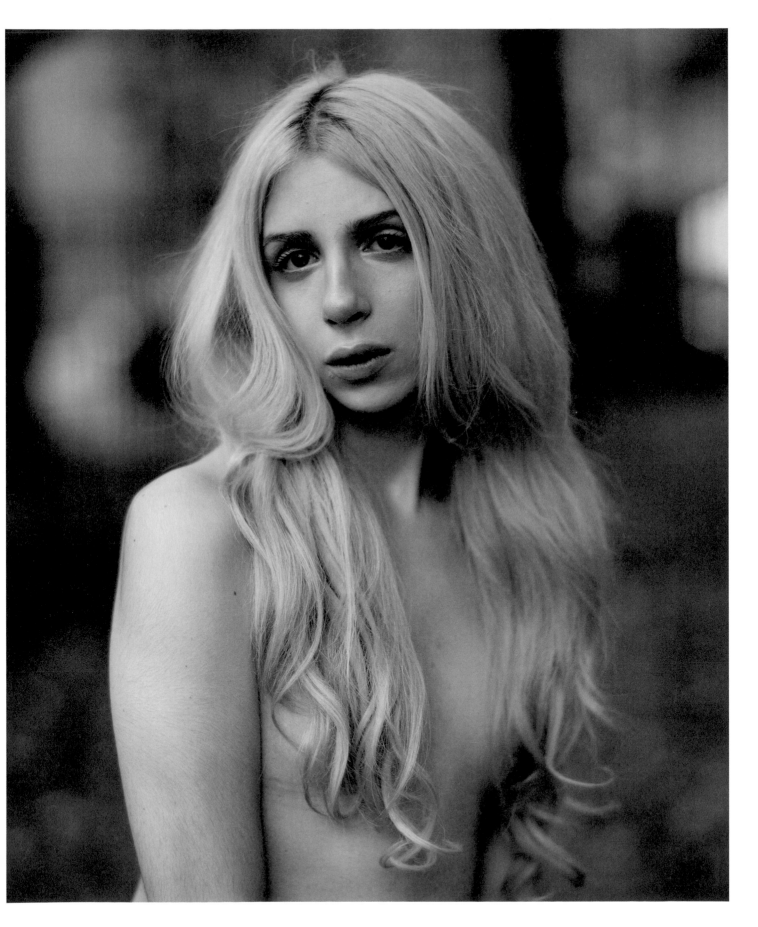

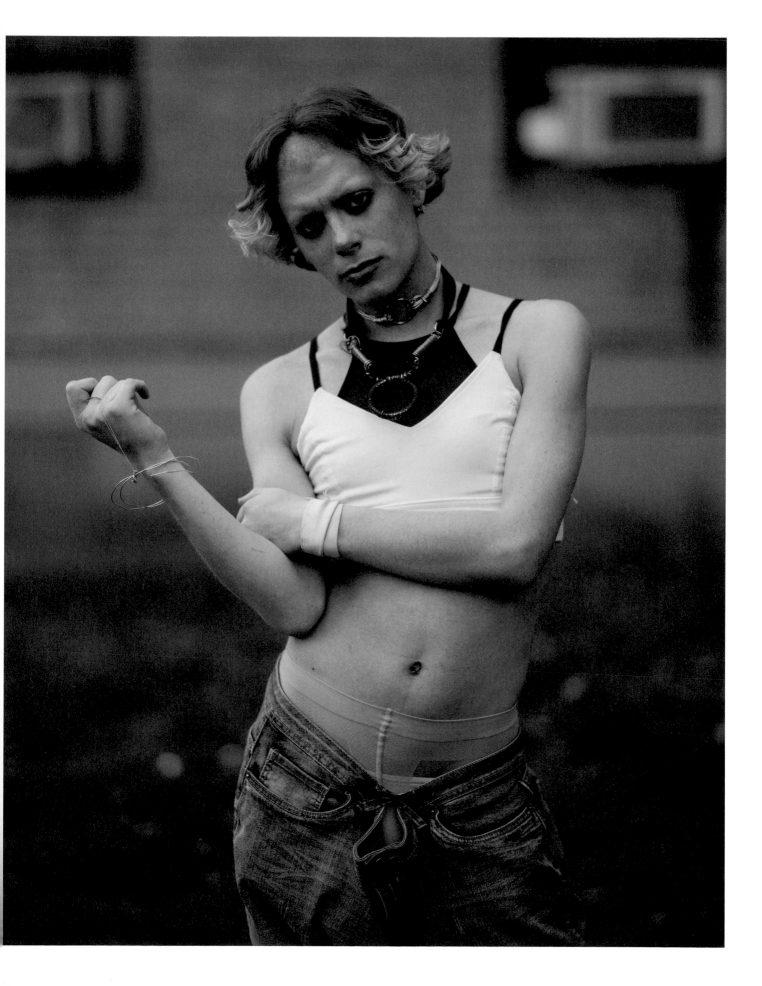

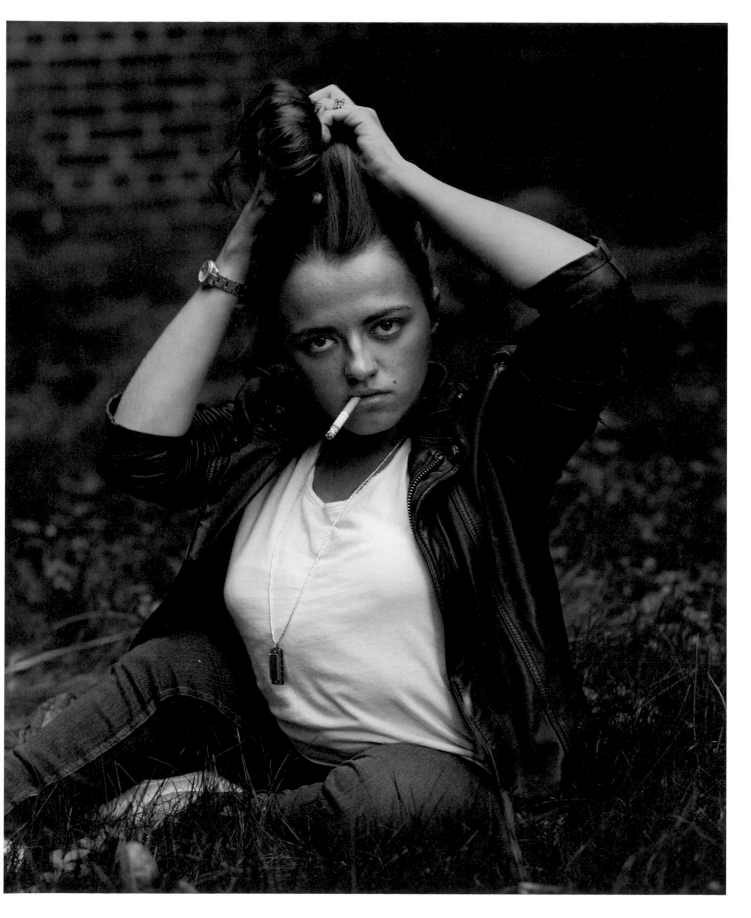

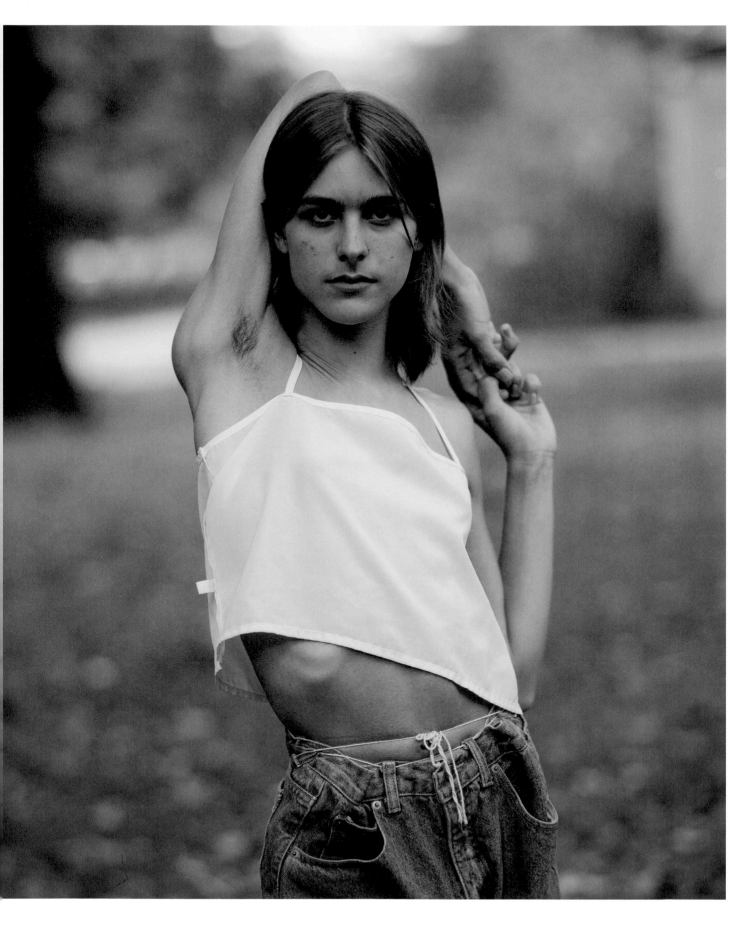

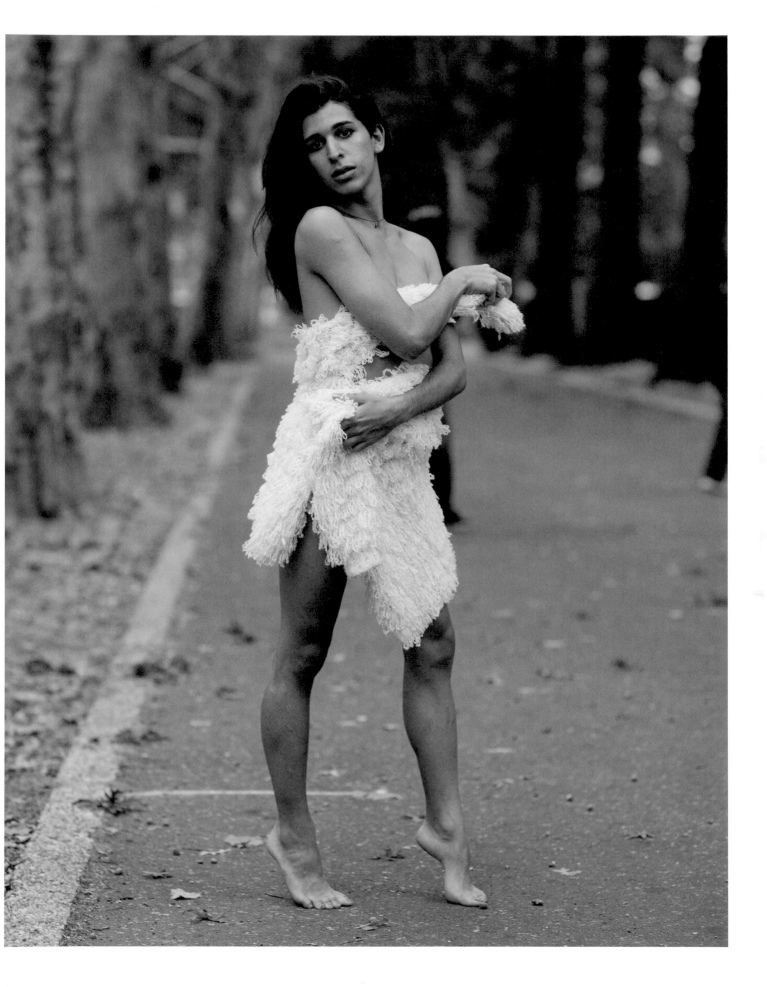

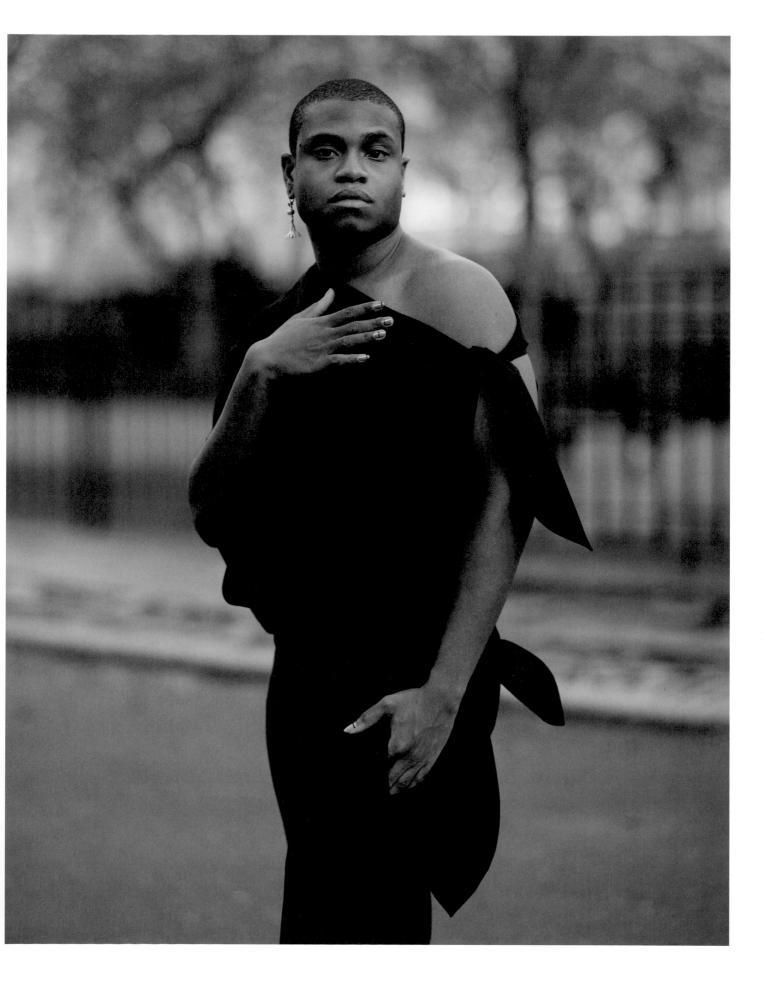

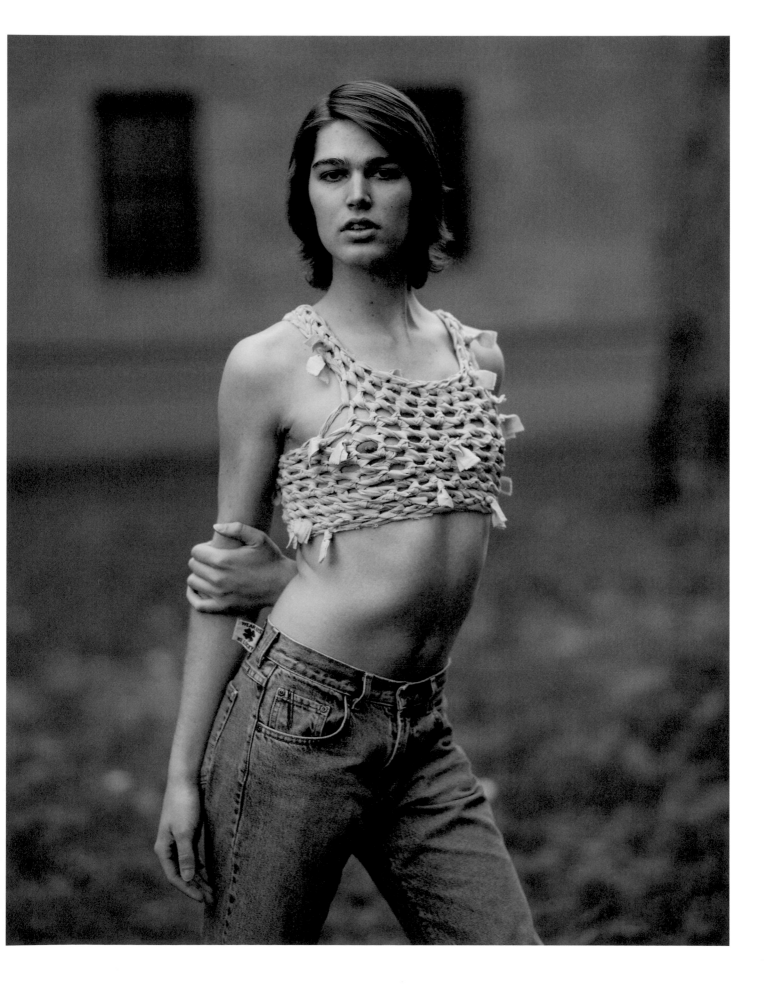

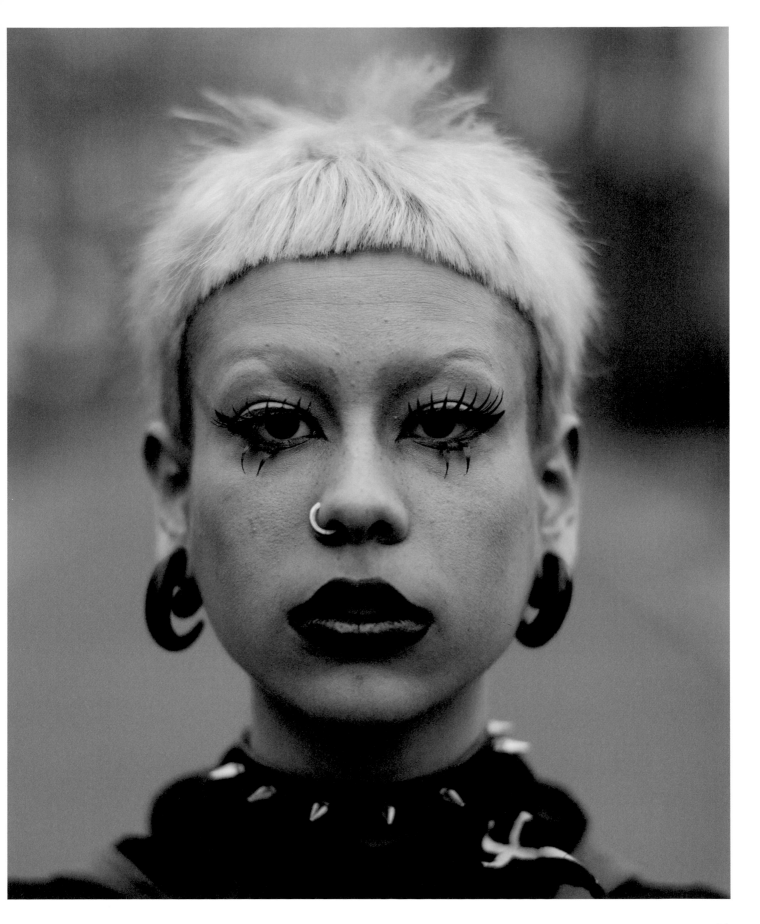

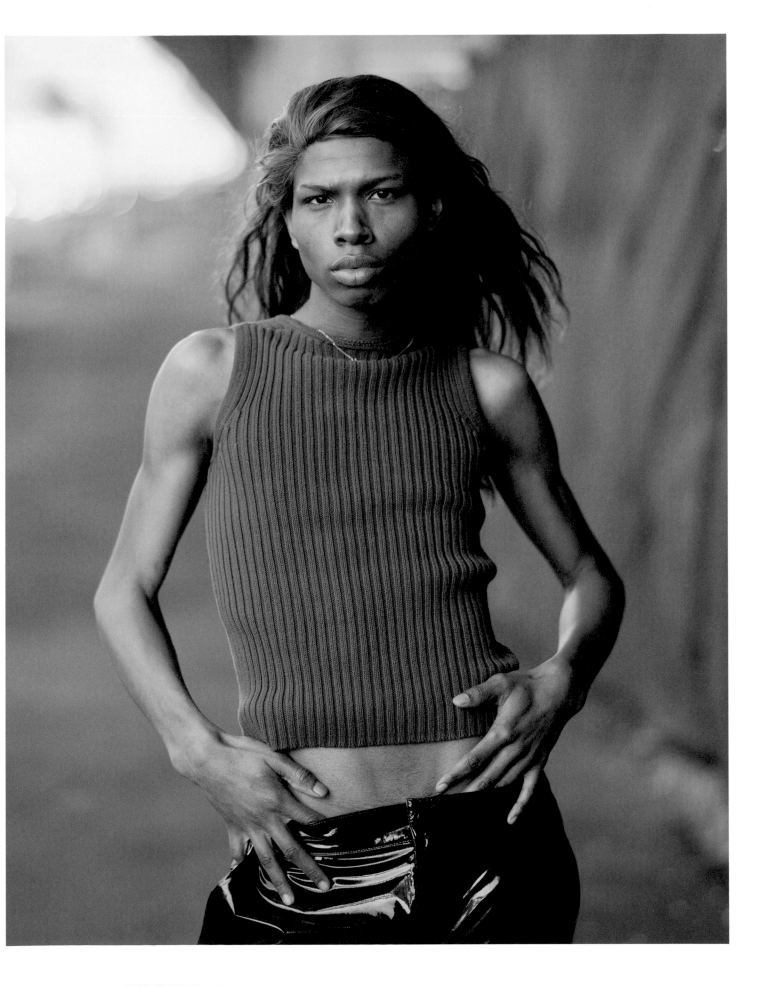

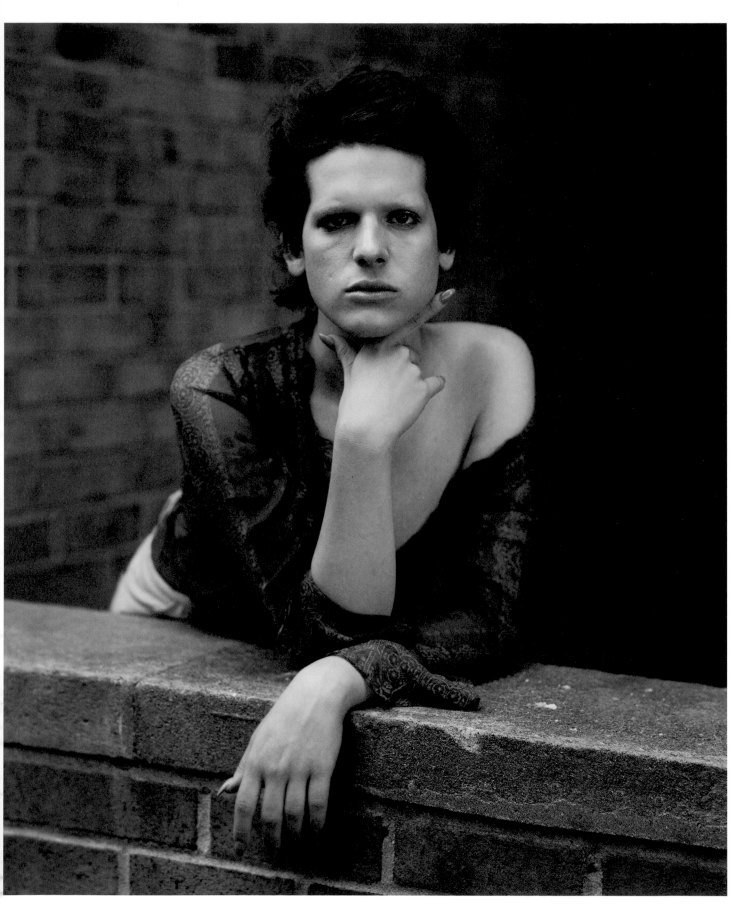

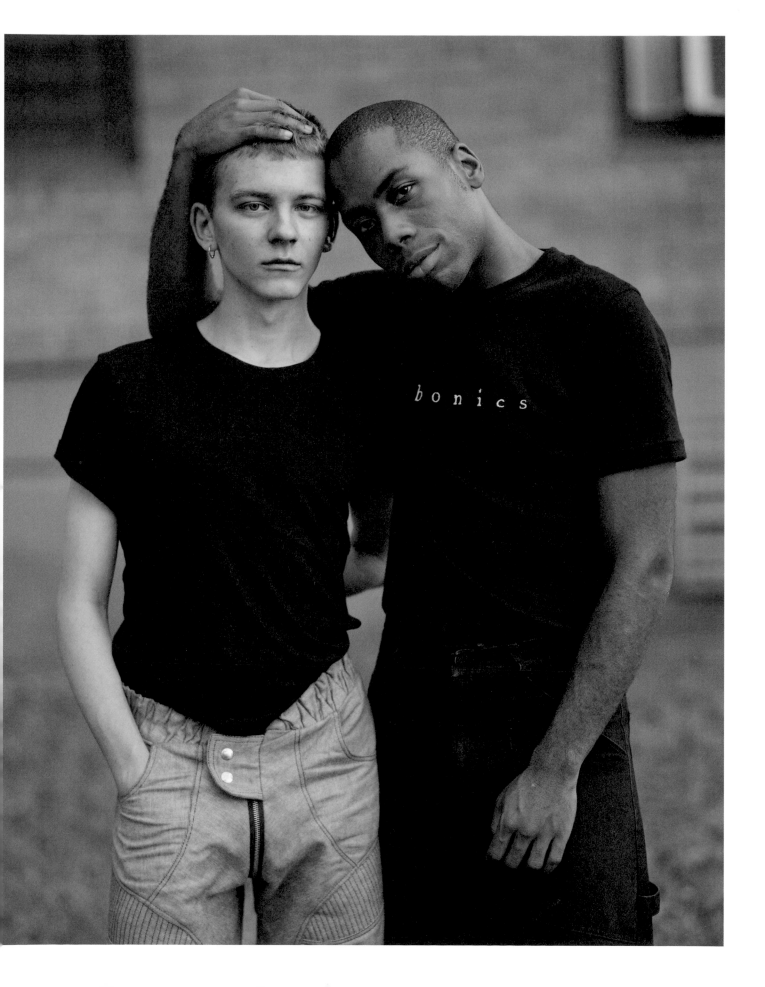

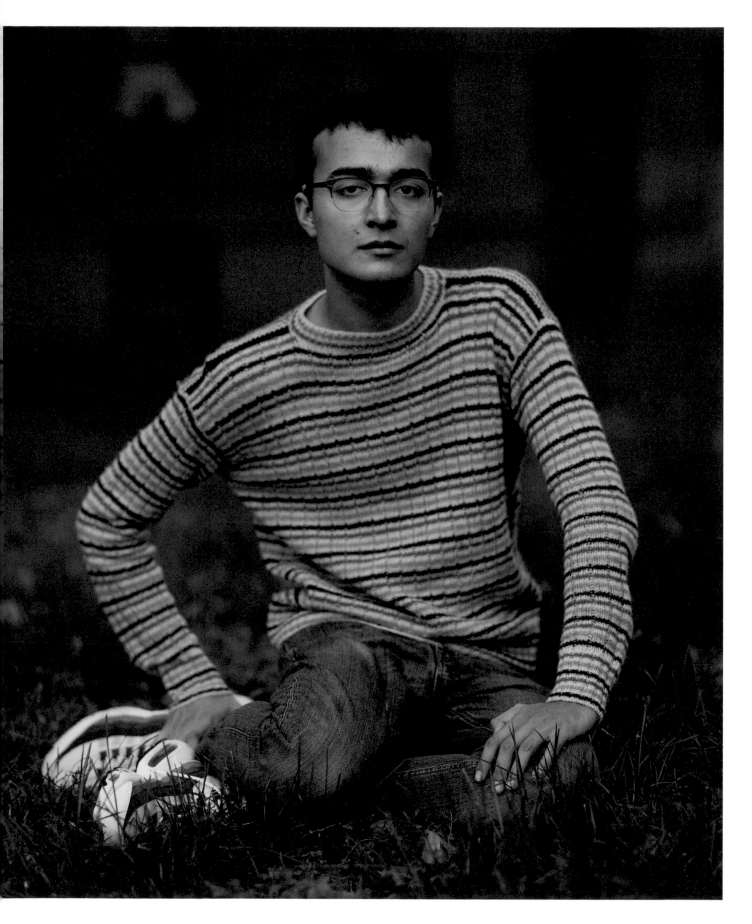

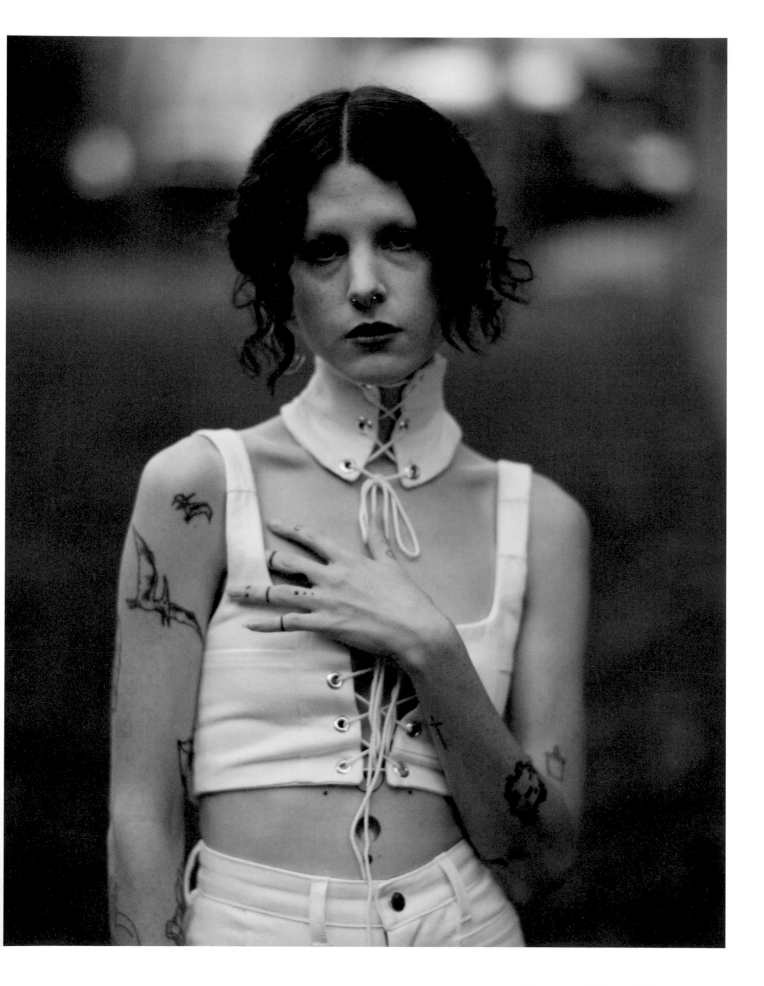

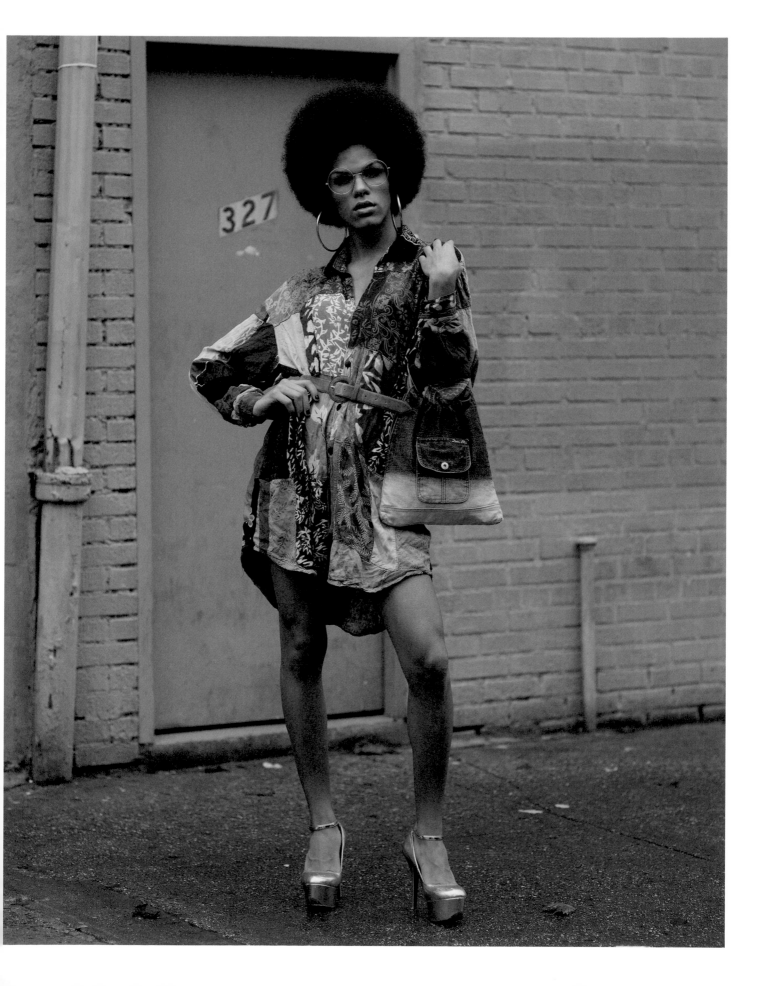

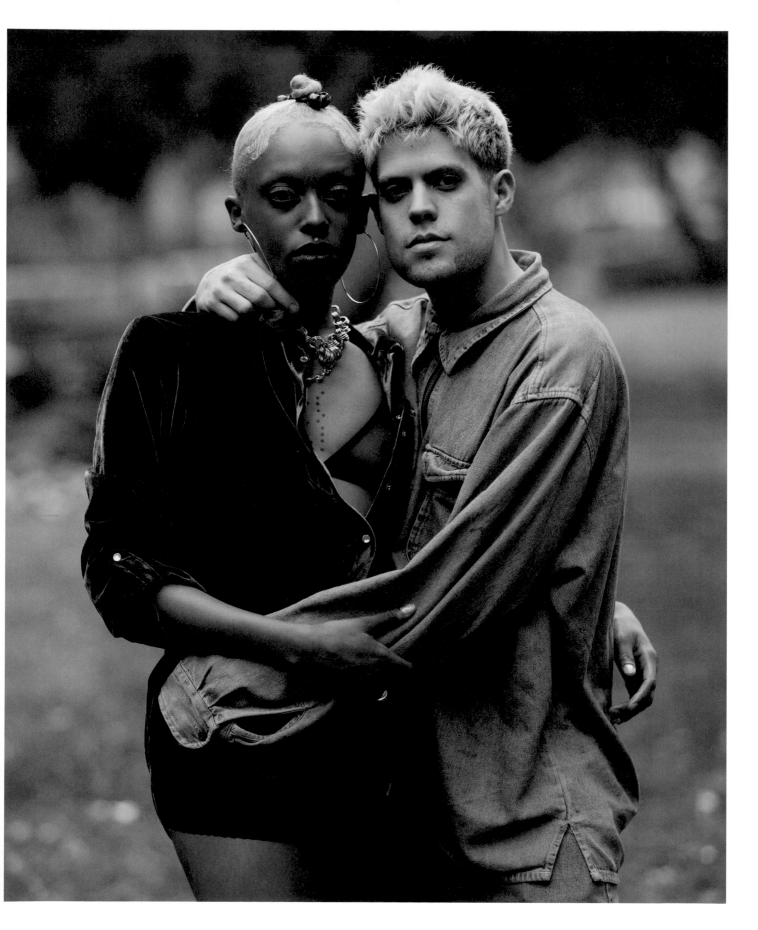

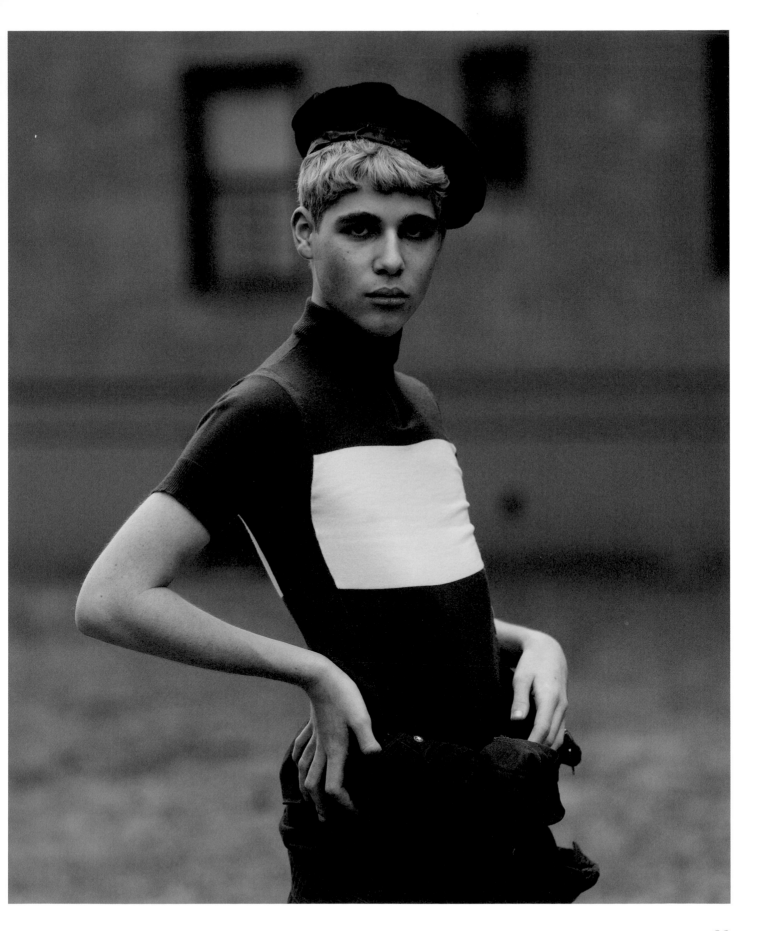

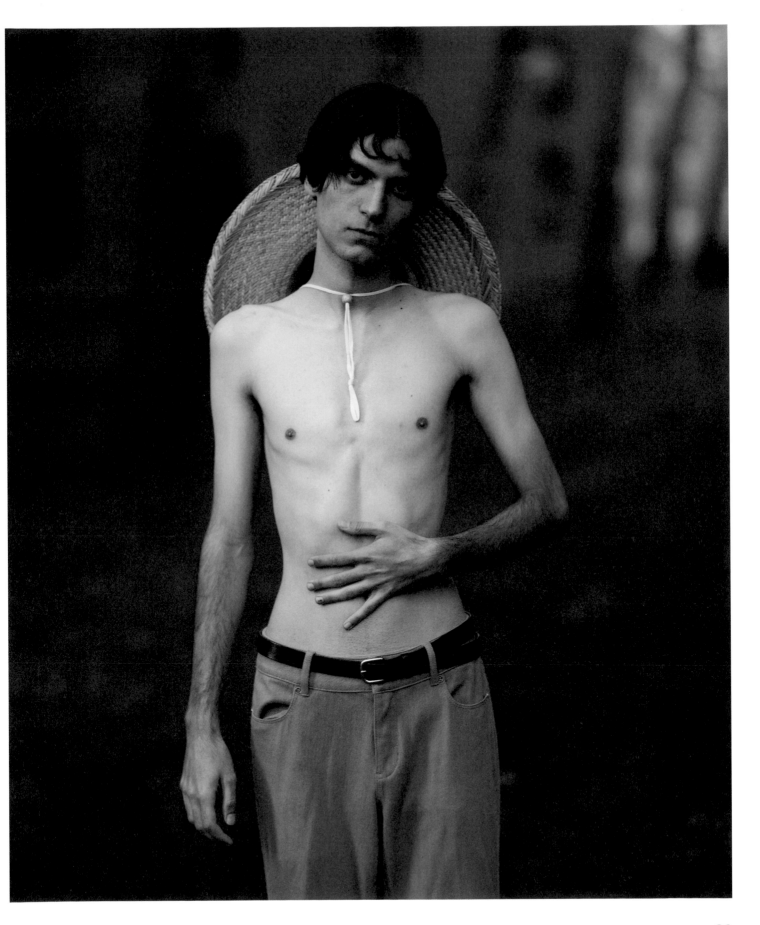

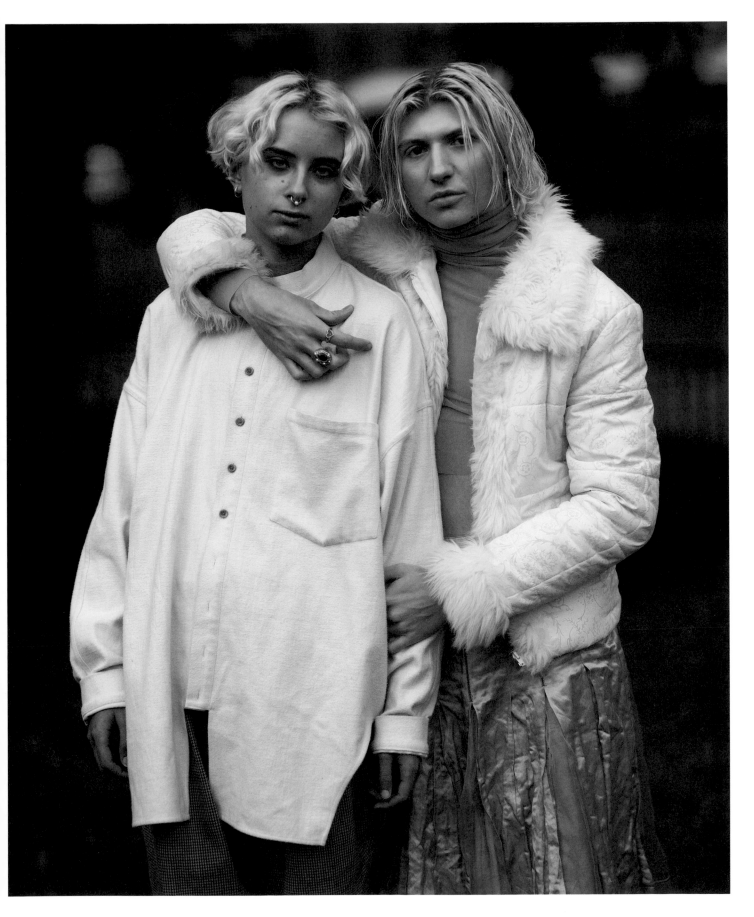

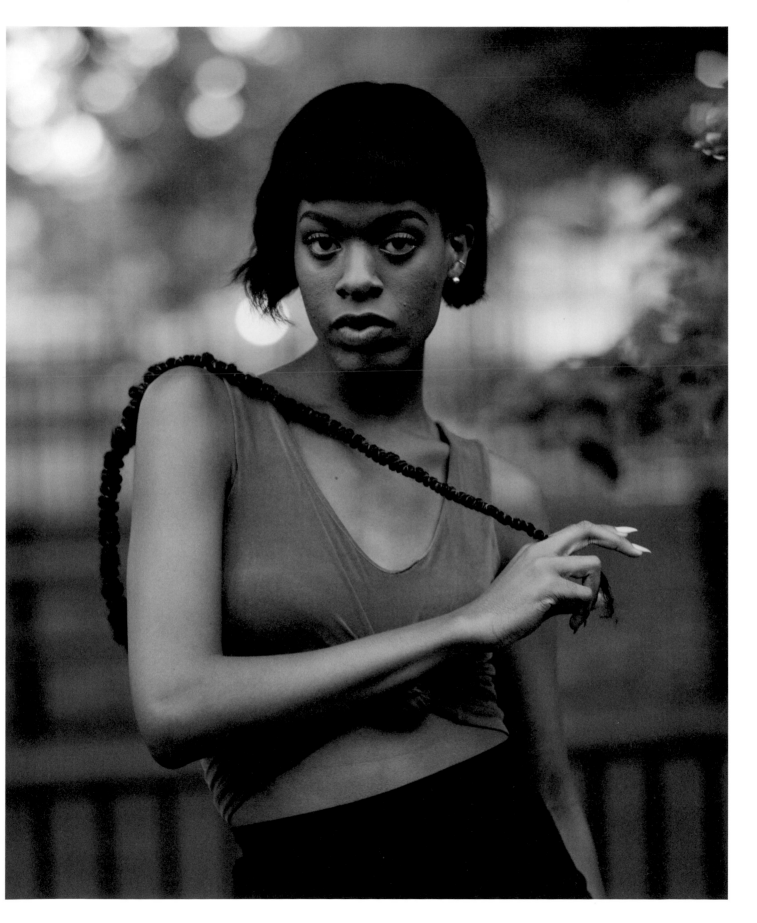

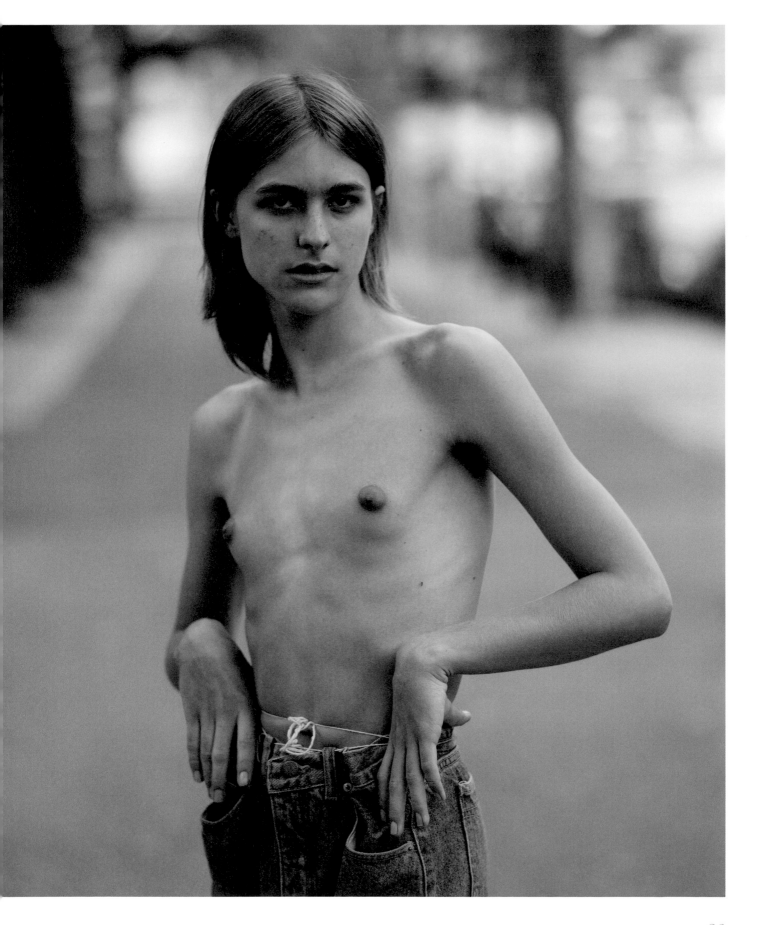

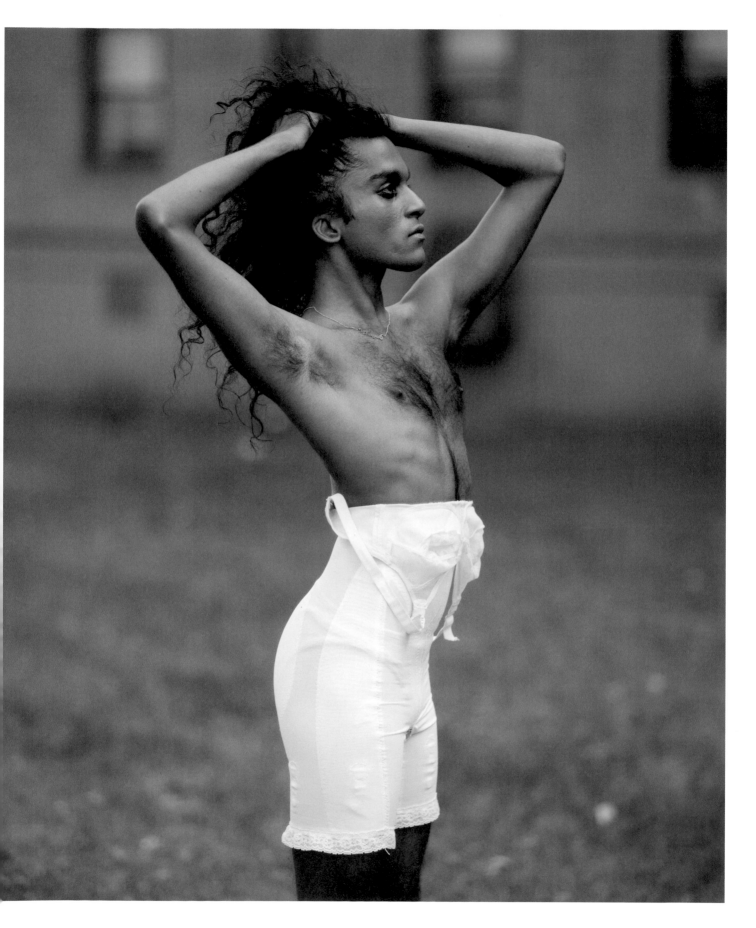

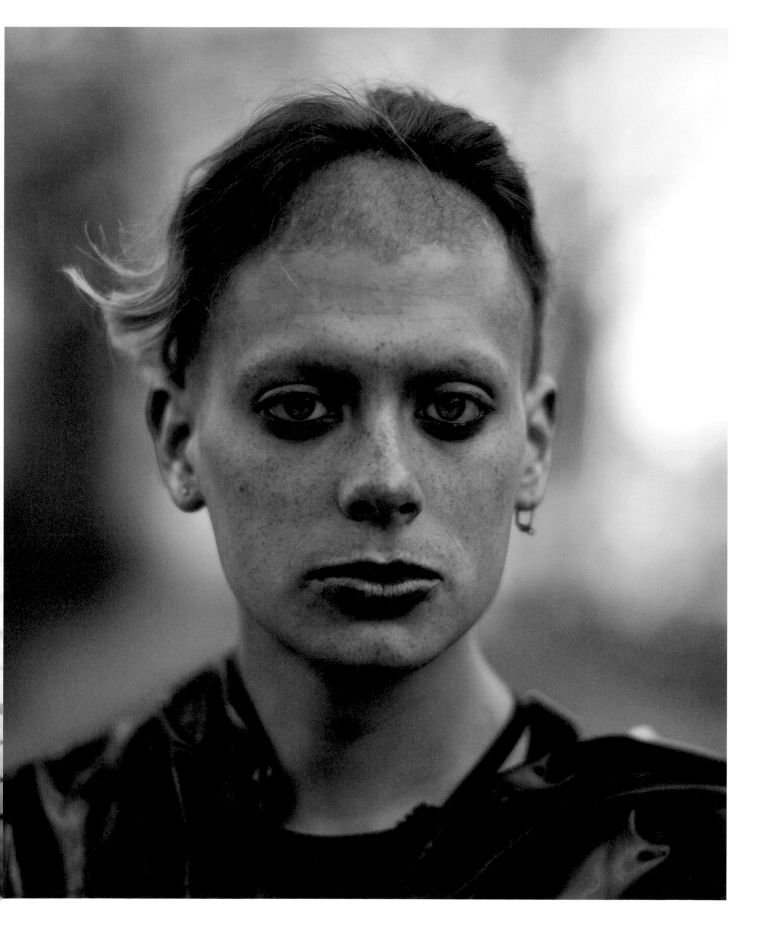

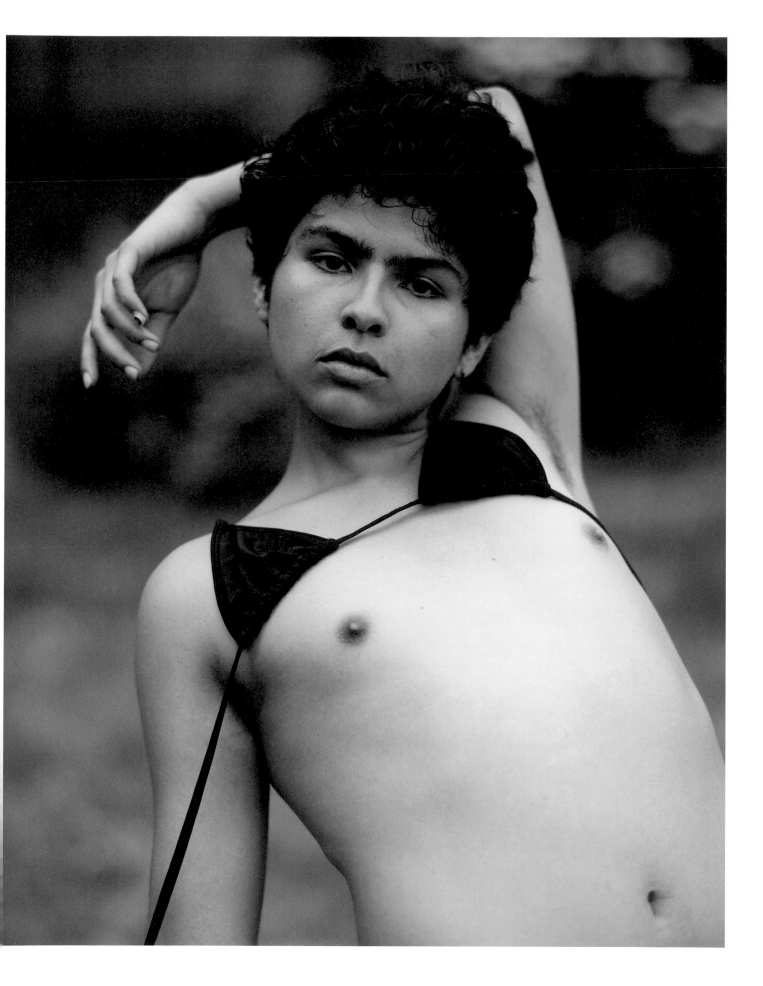

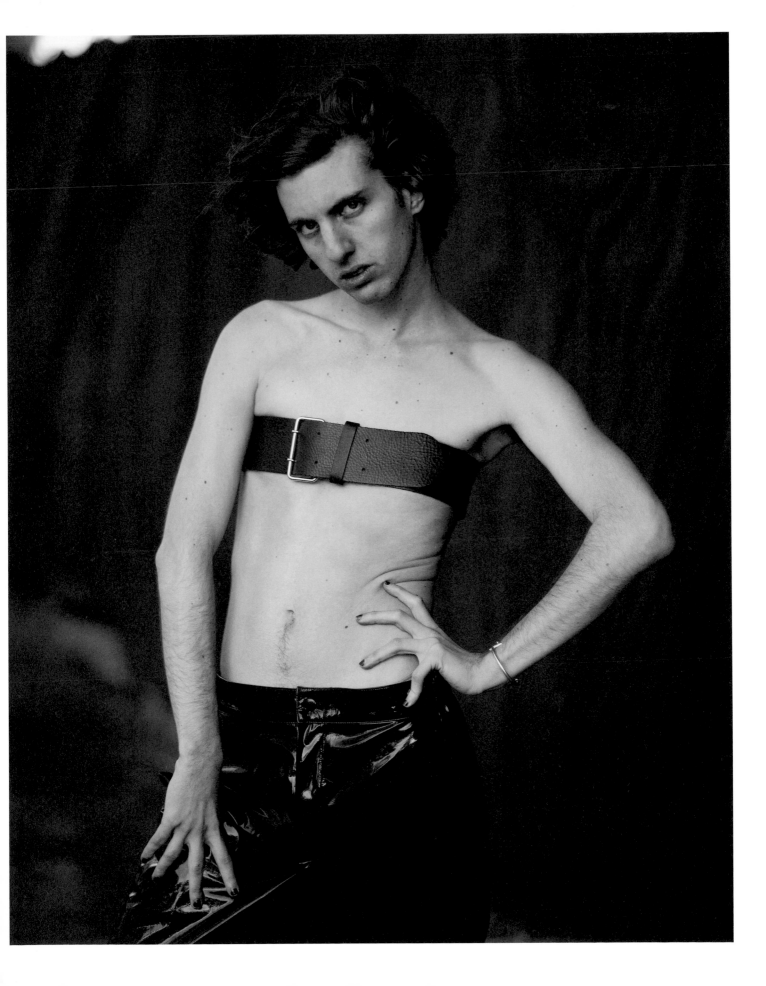

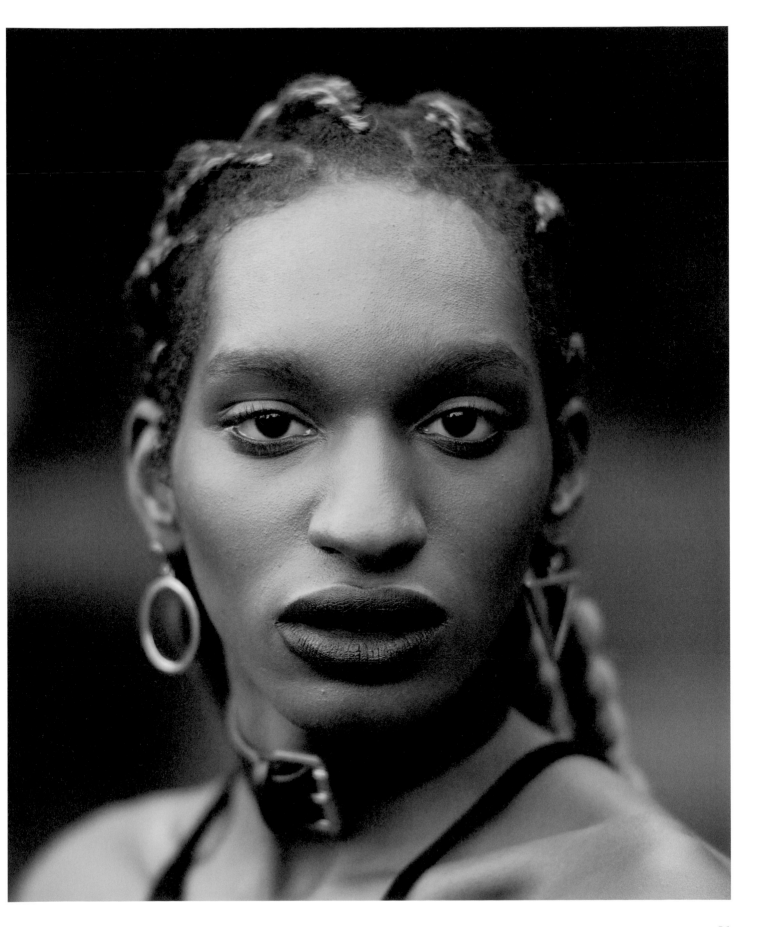

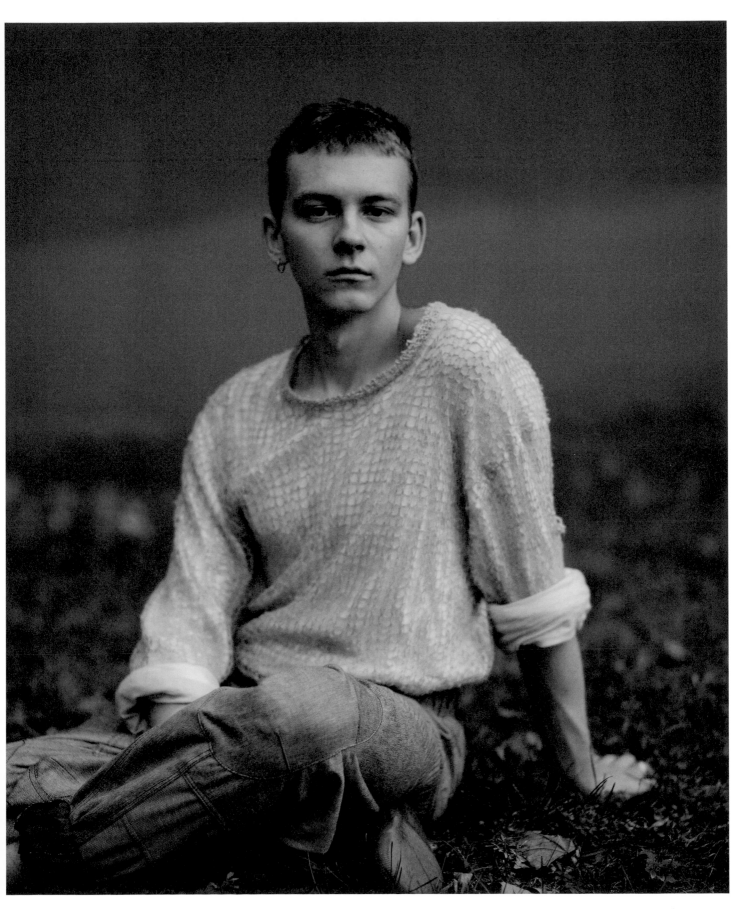

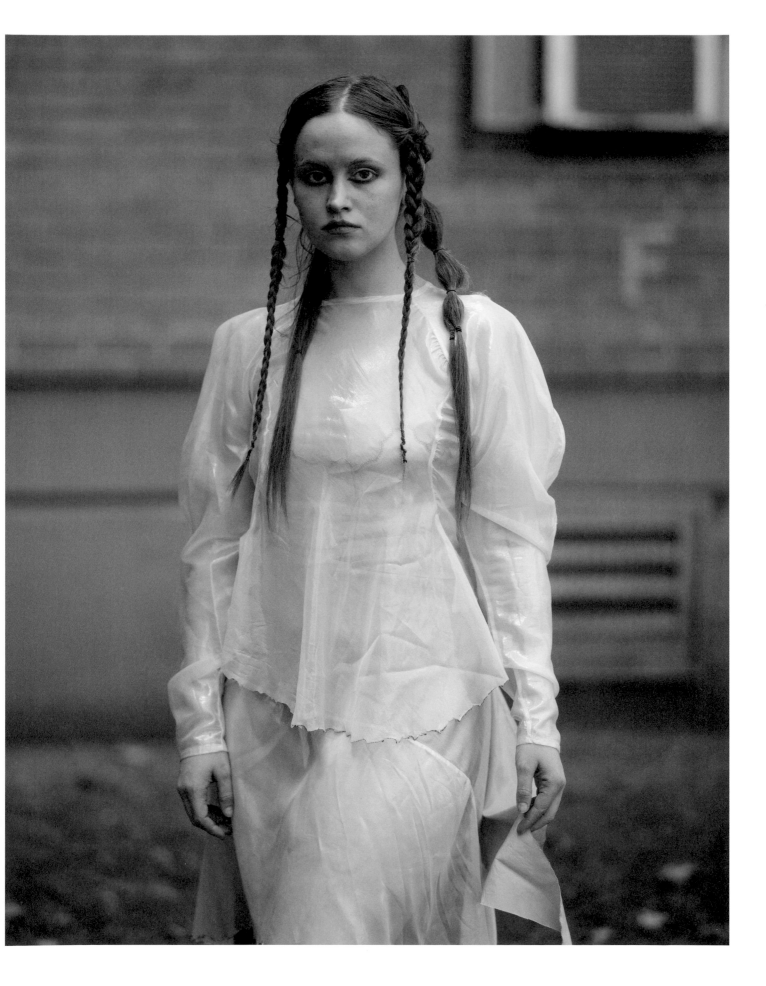

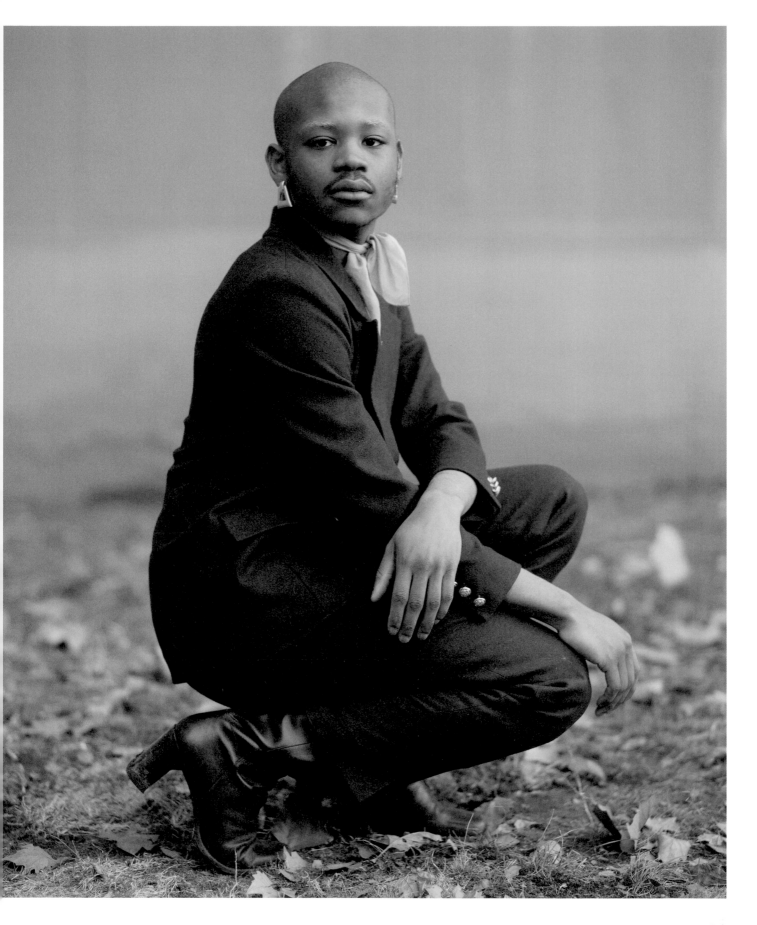

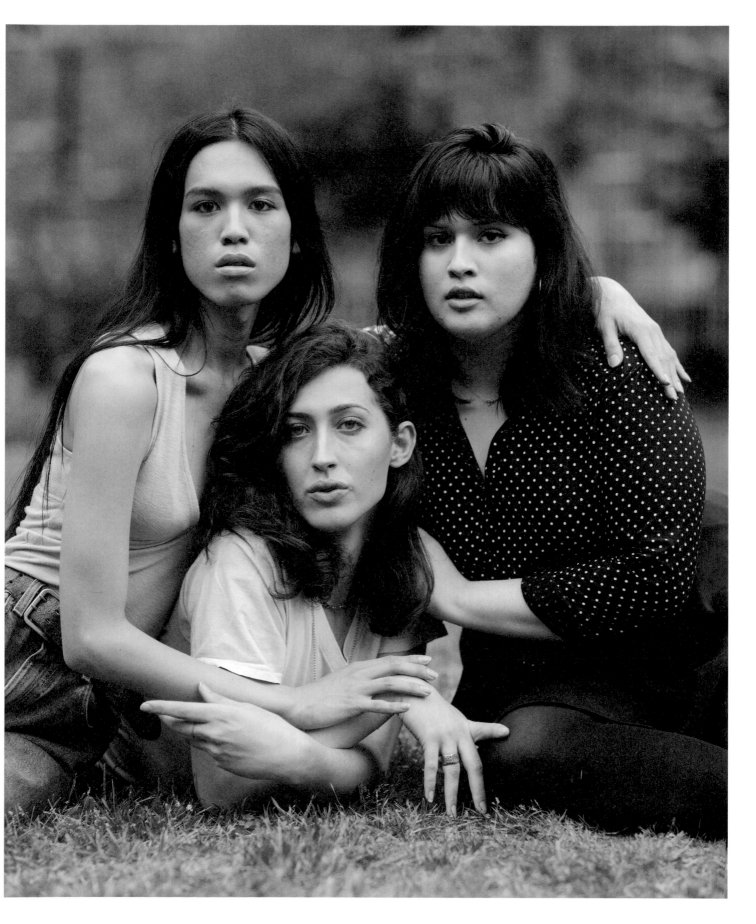

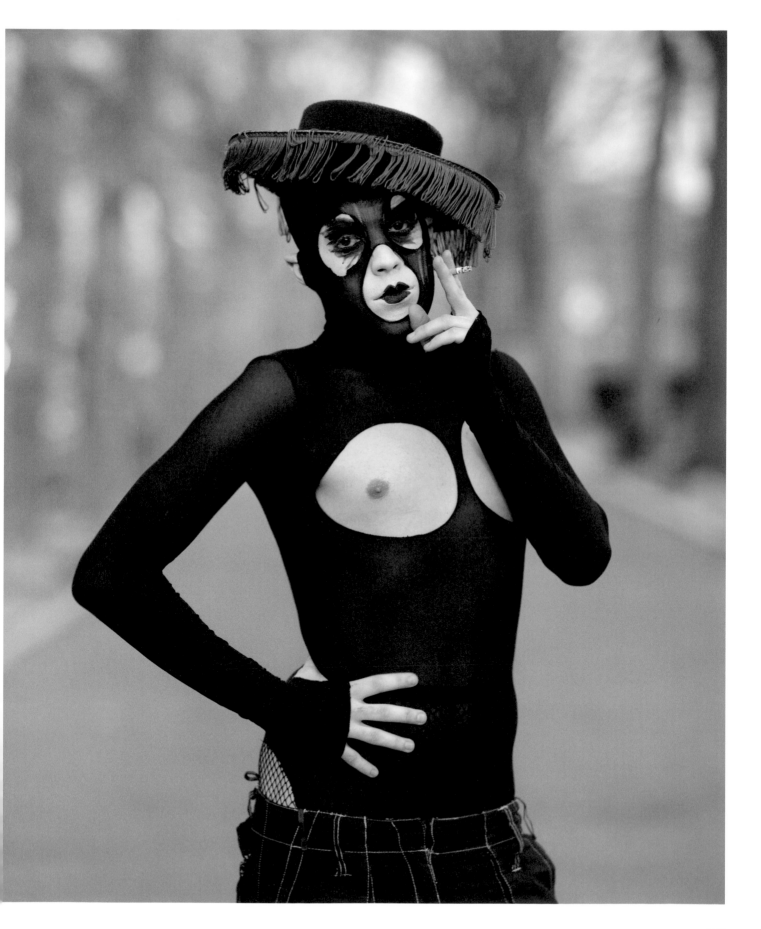

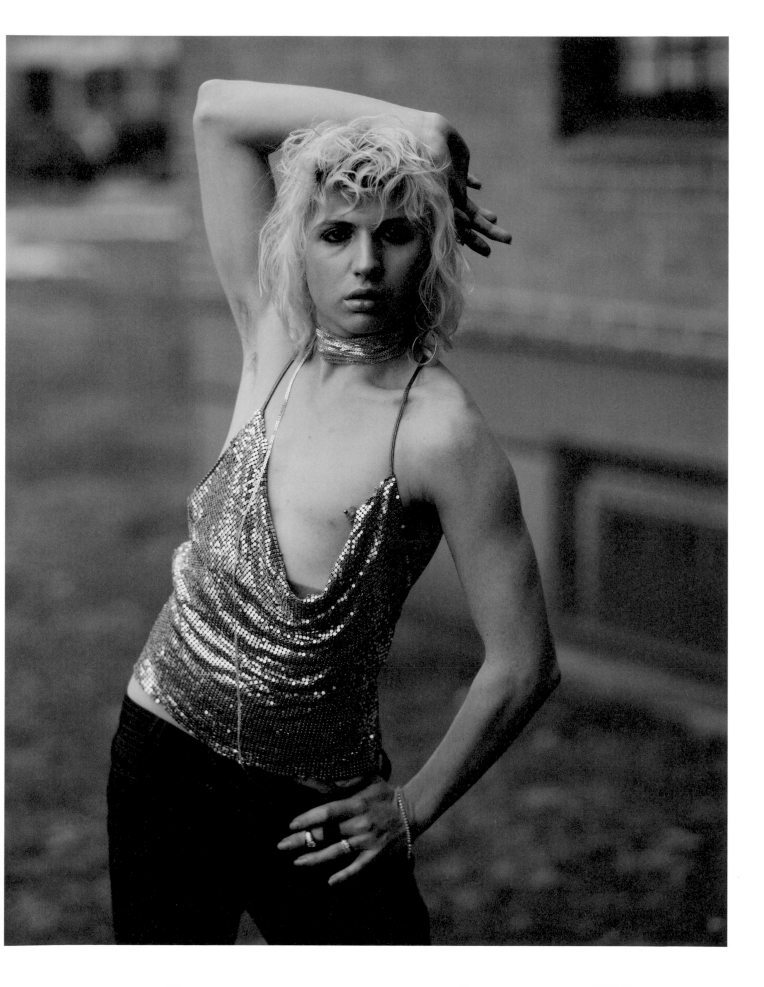

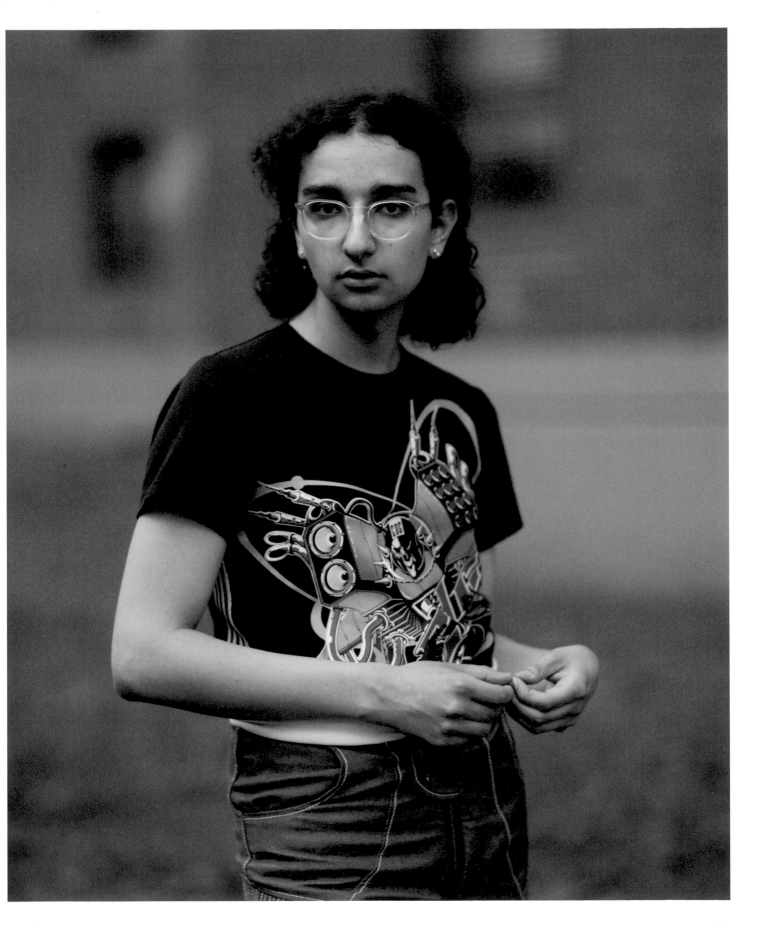

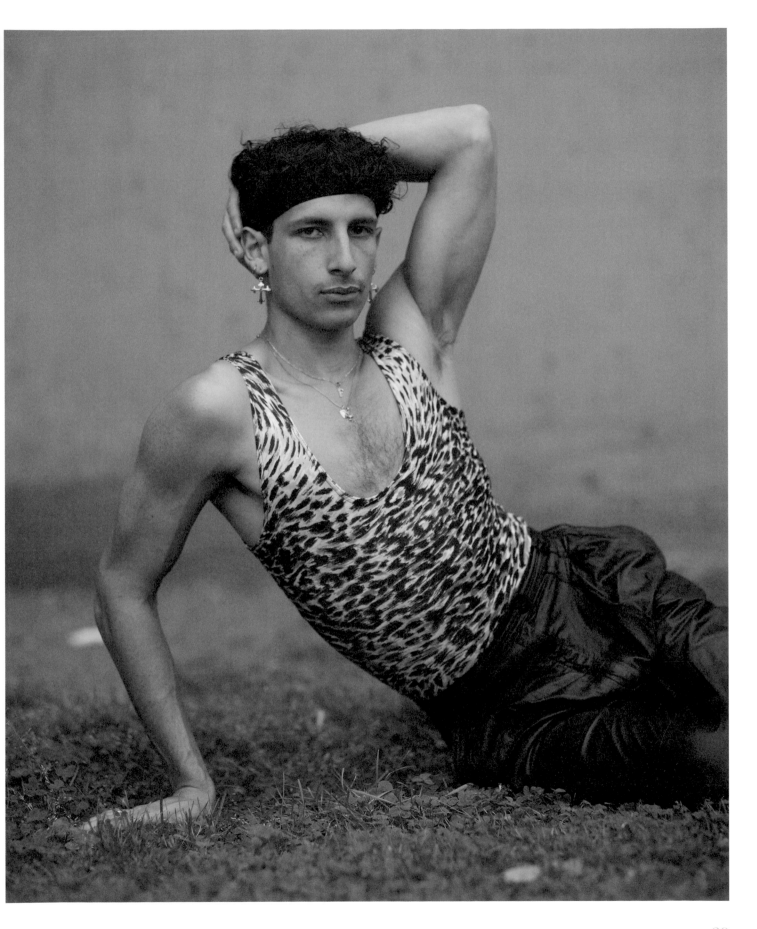

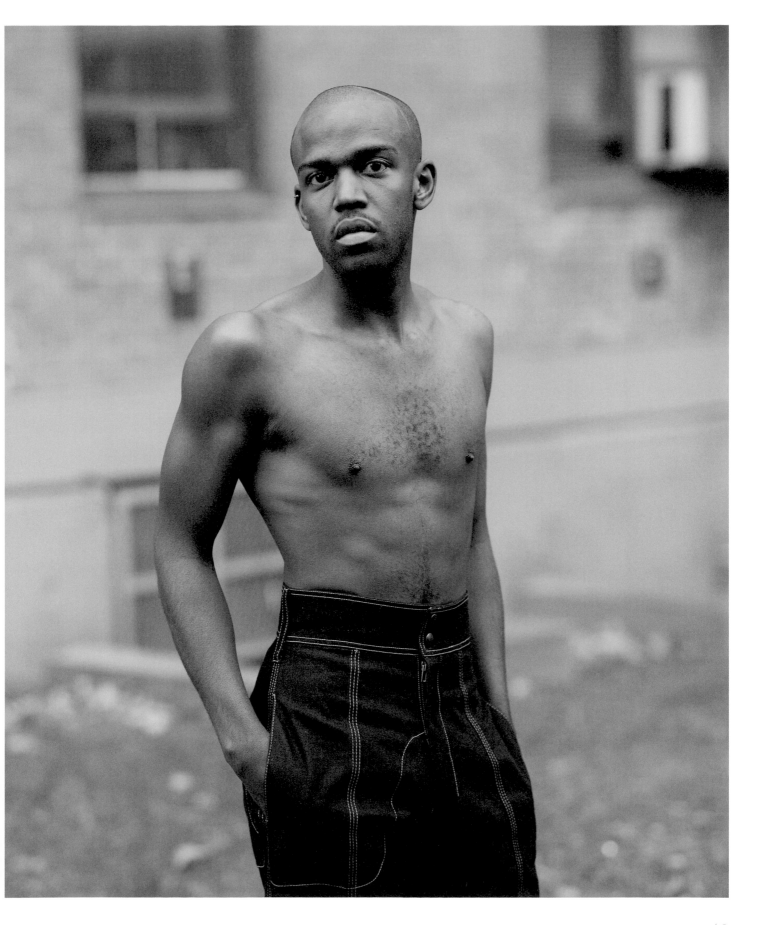

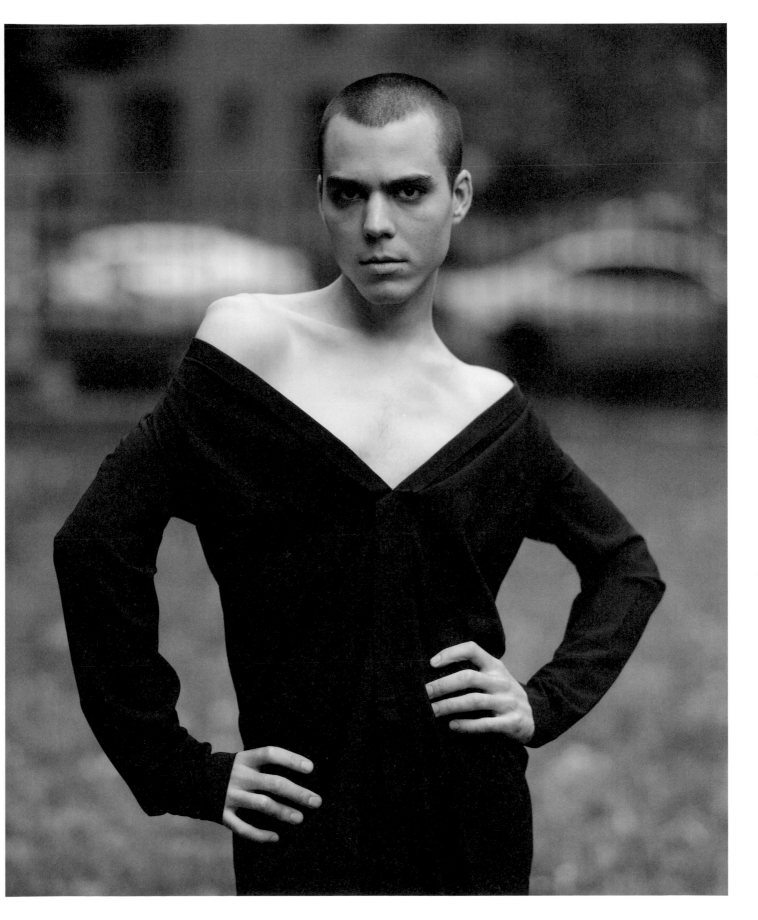

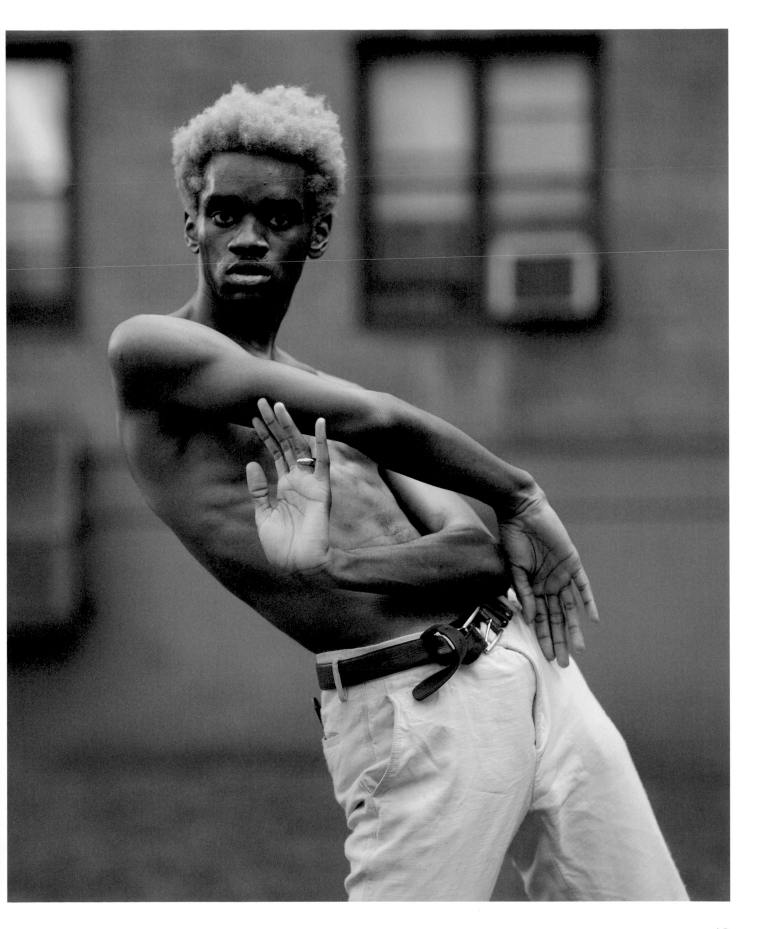

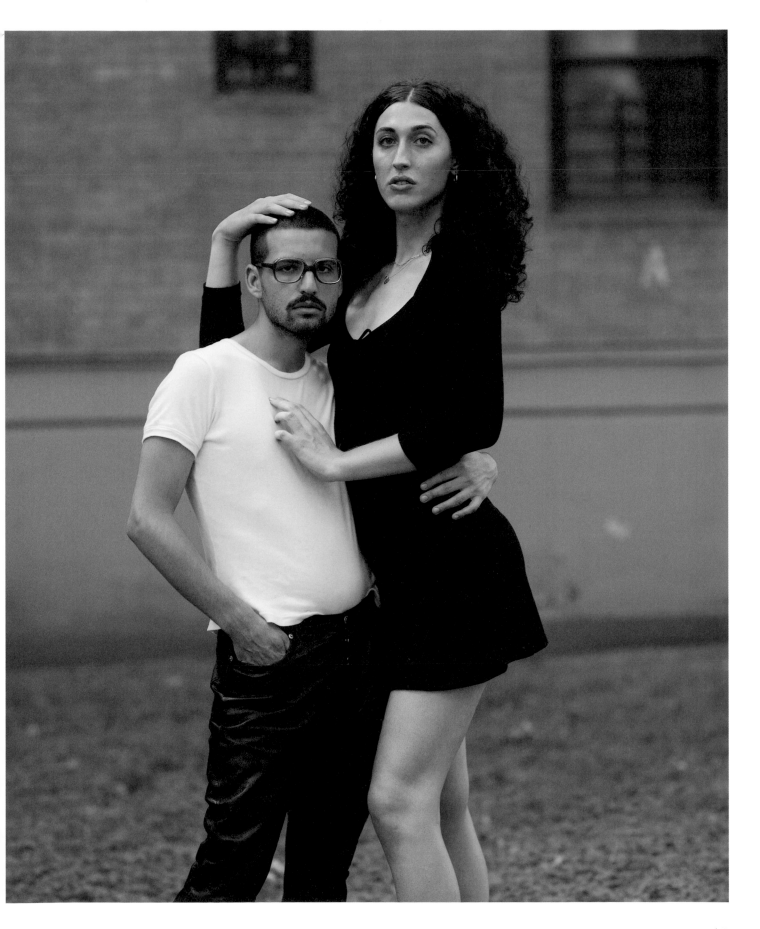

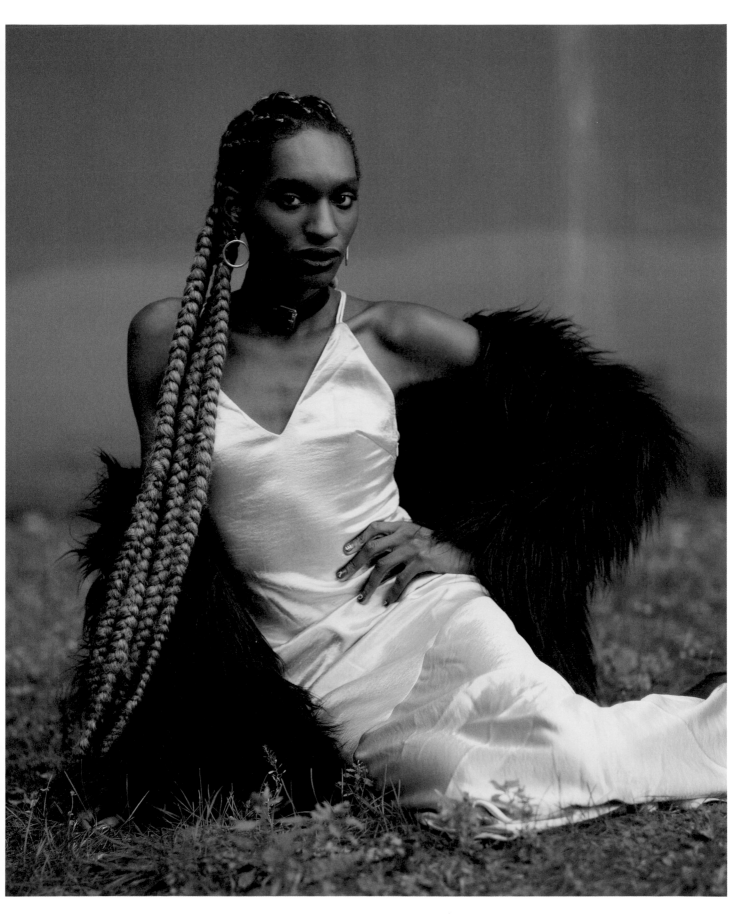

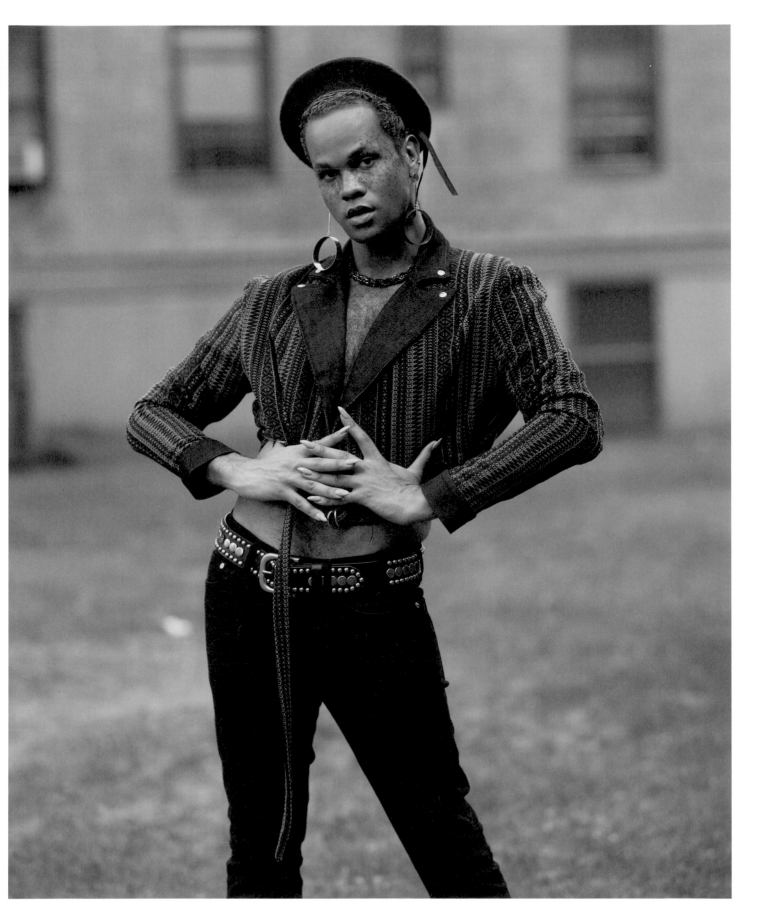

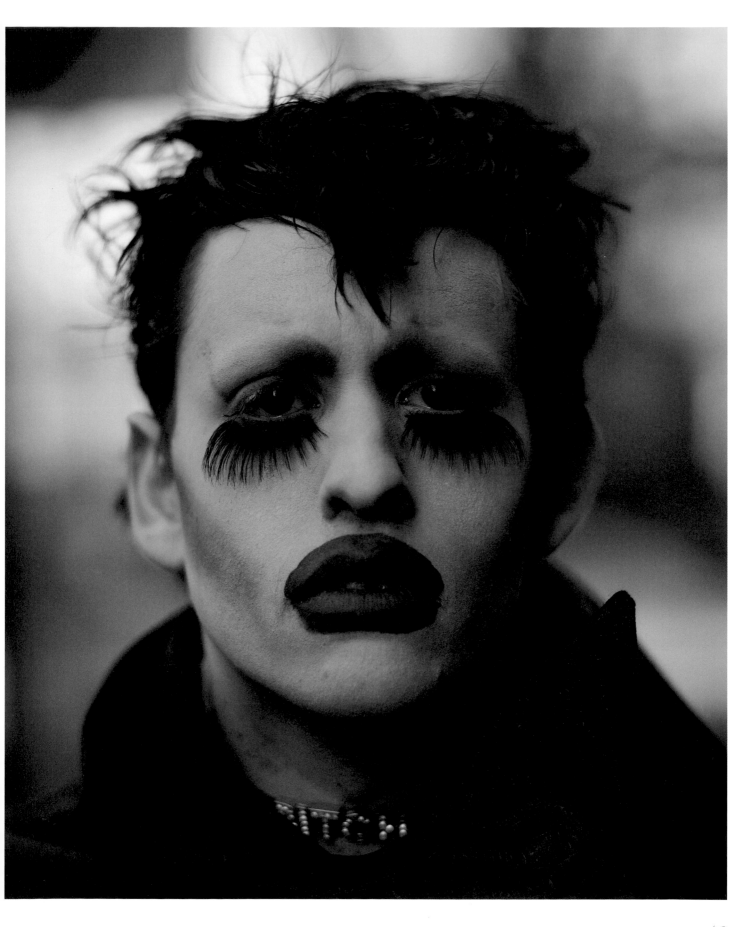

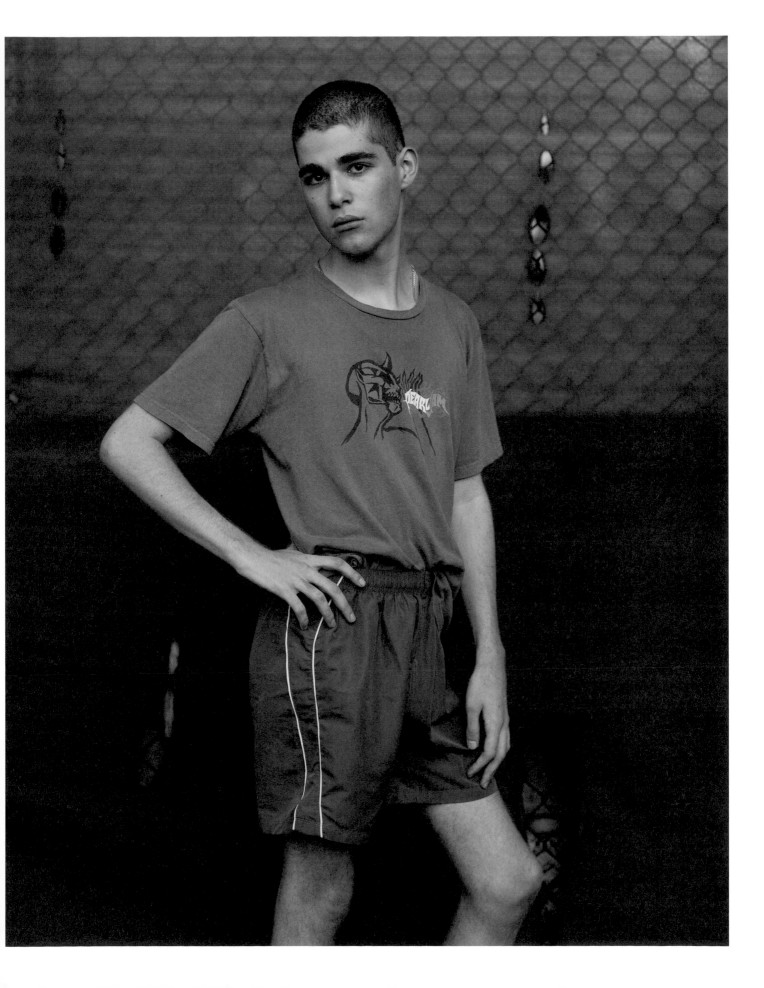

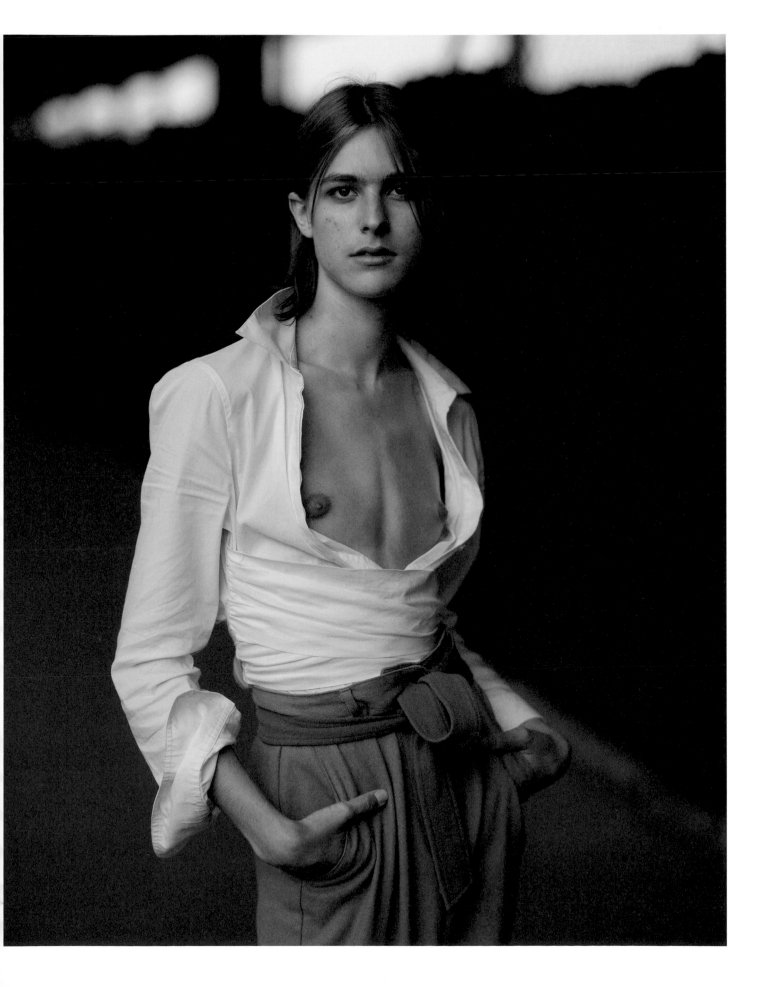

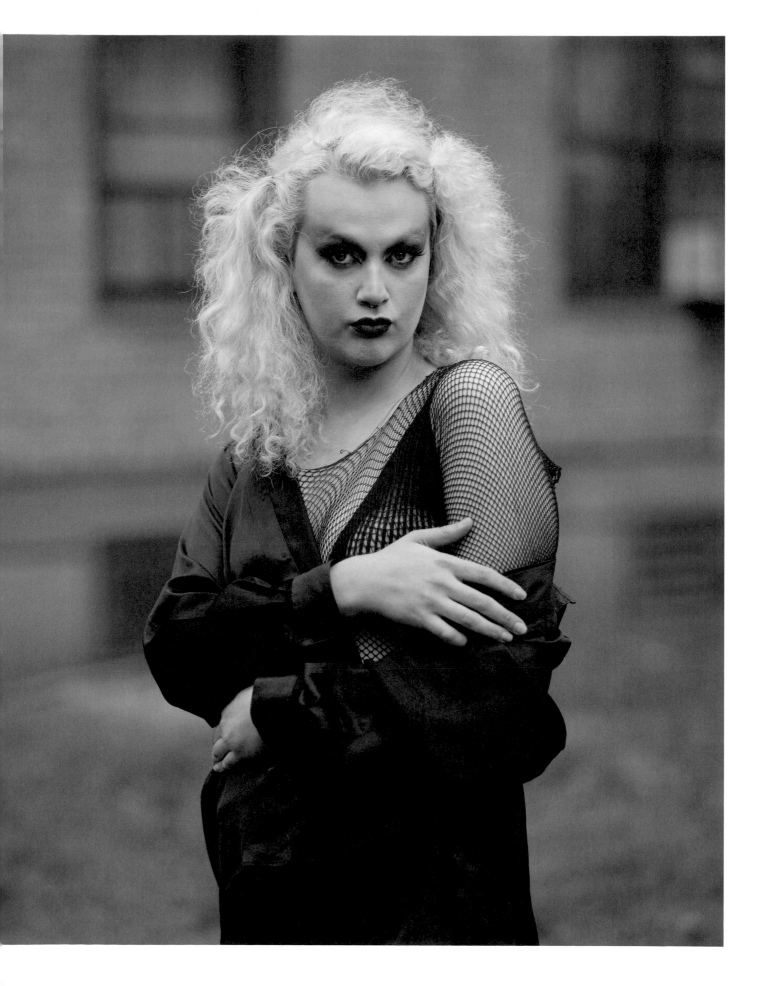

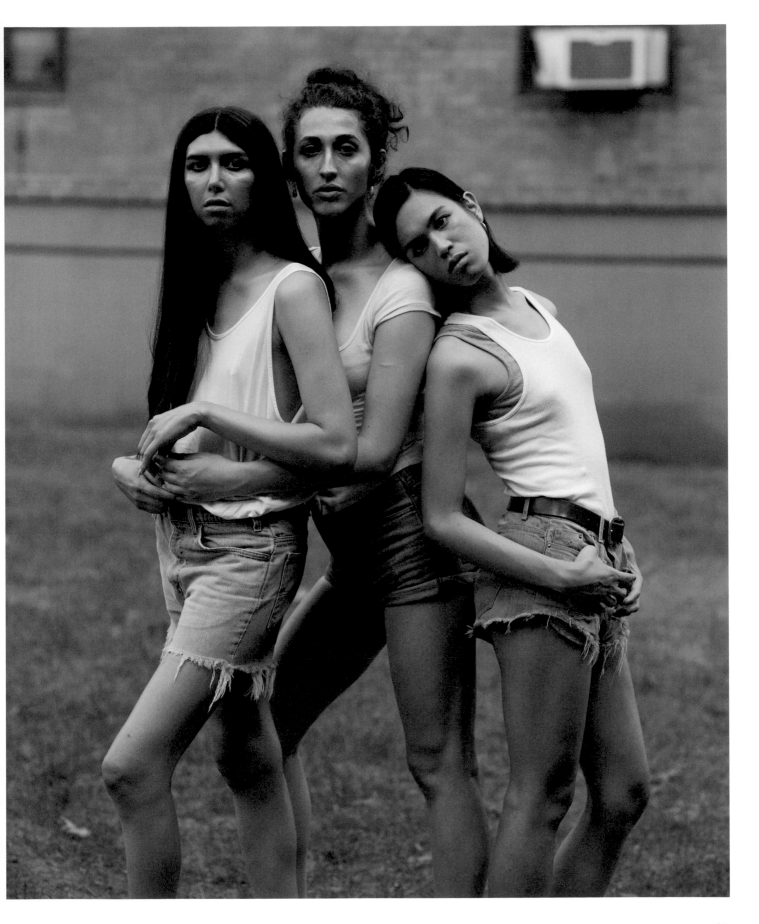

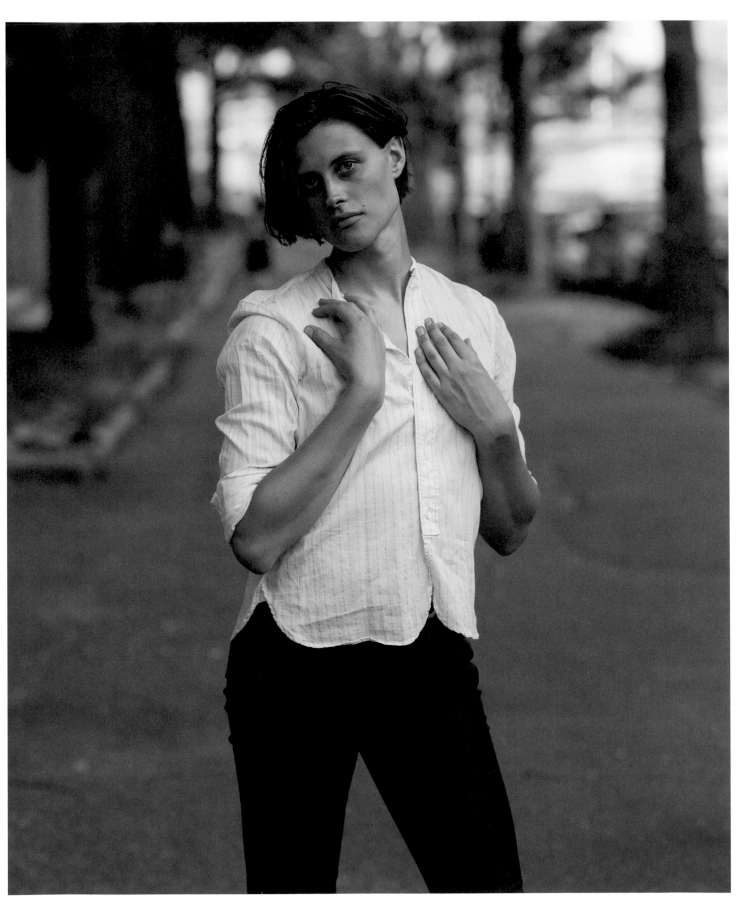

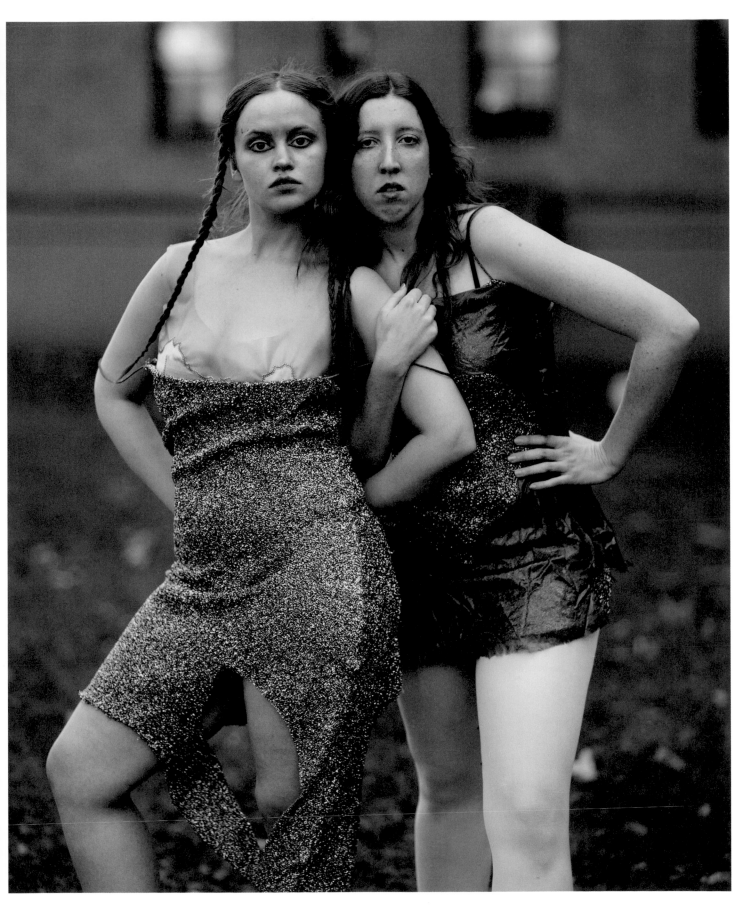

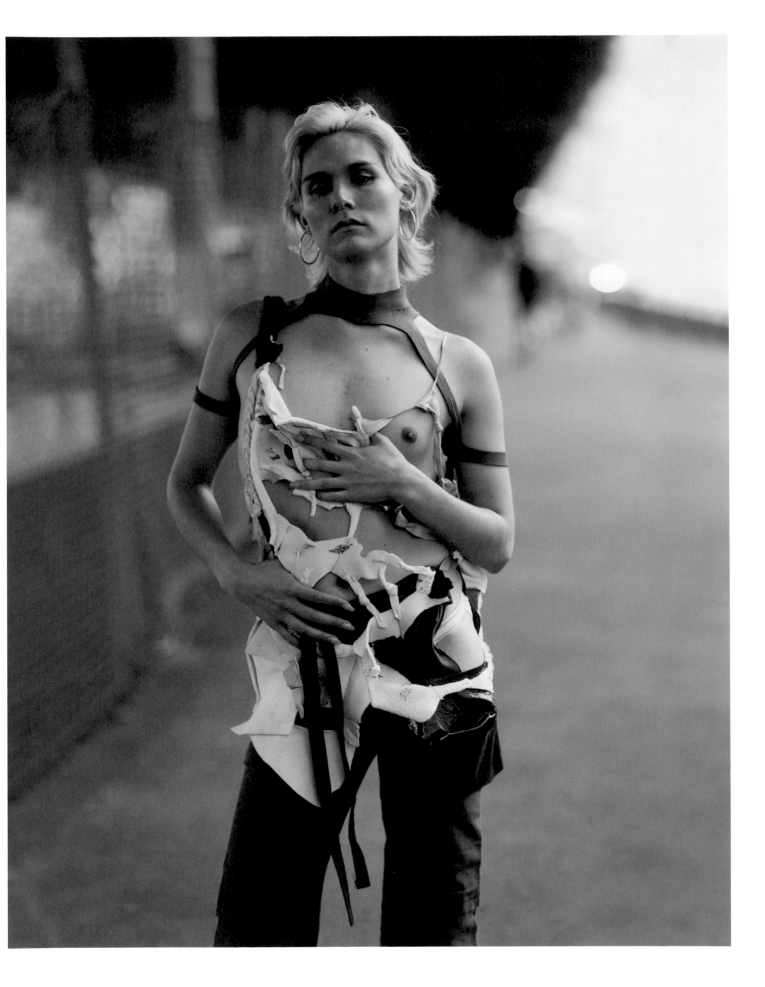

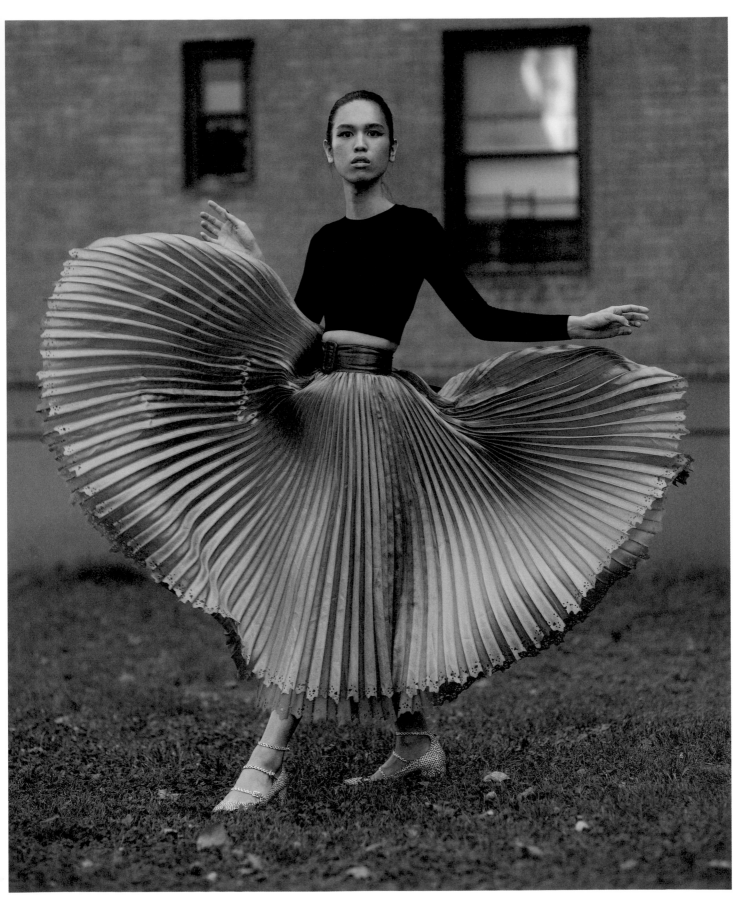

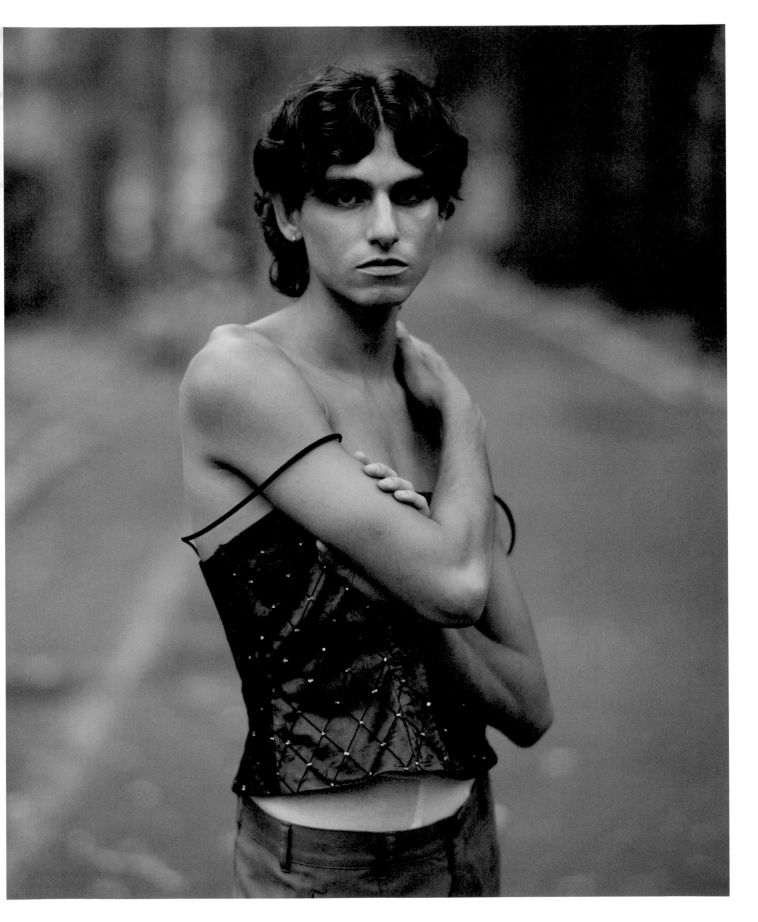

Plates

Ethan James Green (born in Caledonia, Michigan, 1990) has been commissioned by publications such as *Another Man*, *Arena Homme +*, *Dazed & Confused*, *i-D*, *Love Magazine*, *Re-Edition*, *Vanity Fair*, *Vogue Italia*, *Vogue Homme*, *Vogue Paris*, *W*, and *WSJ Magazine* and labels, including Adidas, Alexander McQueen, Dior, Fendi, Helmut Lang, Miu Miu, and Prada. He lives and works in New York.

Hari Nef (foreword) is an actress, model, and writer based in Los Angeles.

Michael Schulman (essay) writes about arts and culture for the *New Yorker* and is the author of *Her Again: Becoming Meryl Streep* (2016).

Ethan James Green
Young New York

Foreword by Hari Nef
Essay by Michael Schulman

Front cover: *Marcs*, 2015

Editor: Brendan Embser
Designer: Victor Balko
Senior Production Manager: True Sims
Production Manager: Nelson Chan
Assistant Editor: Annika Klein
Senior Text Editor: Susan Ciccotti
Copy Editor: Sally Knapp
Work Scholars: Ellen Pong, Kaija Xiao

Additional staff of the Aperture book program
and *Aperture* magazine includes:
Chris Boot, Executive Director; Lesley A. Martin,
Creative Director; Amelia Lang, Associate Pub-
lisher; Taia Kwinter, Managing Editor; Kellie
McLaughlin, Director of Sales and Marketing;
Richard Gregg, Sales Director, Books; Isabelle
McTwigan, Director of Brand Partnerships;
Michael Famighetti, Editor, *Aperture* magazine

Special thanks:
Ethan James Green: Young New York was made pos-
sible, in part, through generous lead support from
Alexander McQueen.

Alexander McQUEEN

Aperture also wishes to thank Peter T. Barbur,
Tom Gildon and Jordan Hancock of M.A.P,
Michael Hoeh, Cathy M. Kaplan, Noel Kirnon,
Fred Ohm, Missy and Jim O'Shaughnessy, and
Drs. Stephen and Marcia Silberstein for their con-
tributions to making this project possible.

Compilation—including selection, placement,
and order of text and images—copyright © 2019
Aperture Foundation, Inc.; photographs copyright
© 2019 Ethan James Green; foreword copyright
© 2019 Hari Nef; "Young New York" copyright
© 2019 Michael Schulman. All rights reserved
under International and Pan-American Copyright
Conventions. No part of this book may be repro-
duced in any form whatsoever without written
permission from the publisher.

First edition, 2019
Printed by Artron in China
Separations by Echelon, Santa Monica, California
10 9 8 7 6 5 4 3 2 1

Library of Congress Control Number: 2018961597
ISBN 978-1-59711-454-7

To order Aperture books, contact:
+1 212.946.7154
orders@aperture.org

For information about Aperture trade distribution
worldwide, visit:
aperture.org/distribution

aperture

Aperture Foundation
547 West 27th Street, 4th Floor
New York, NY 10001
aperture.org

Aperture, a not-for-profit foundation, connects
the photo community and its audiences with the
most inspiring work, the sharpest ideas, and with
each other—in print, in person, and online.